EXCELLENCE IN GLASS ART

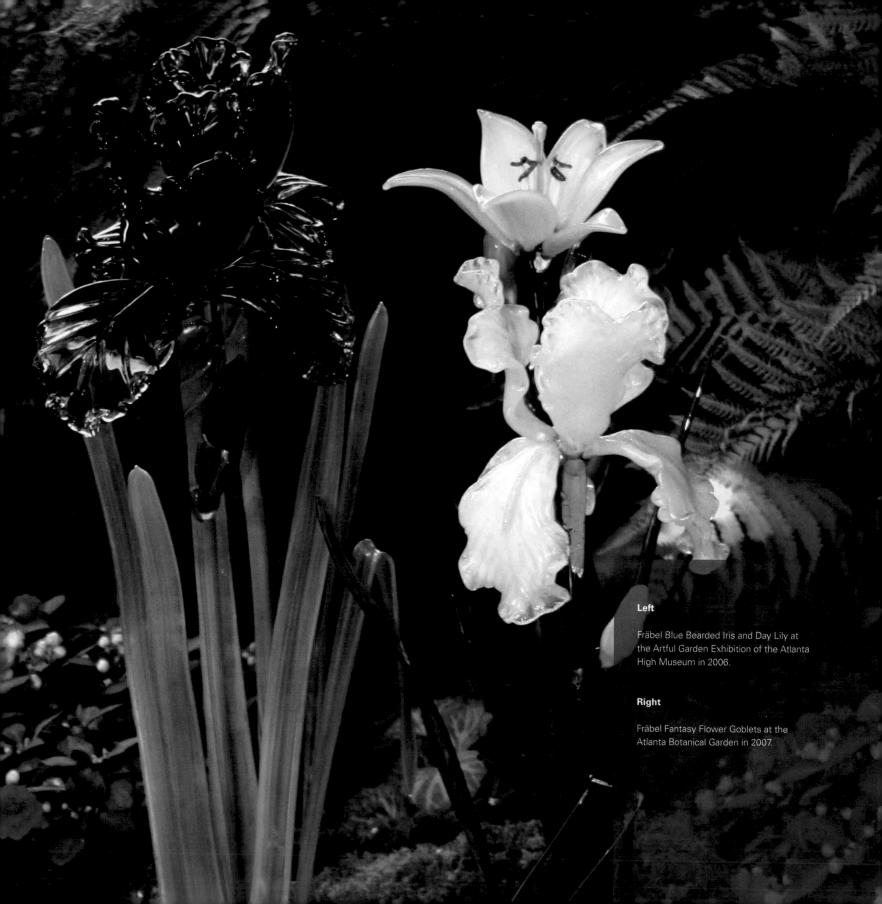

Left

Fräbel Blue Bearded Iris and Day Lily at the Artful Garden Exhibition of the Atlanta High Museum in 2006.

Right

Fräbel Fantasy Flower Goblets at the Atlanta Botanical Garden in 2007.

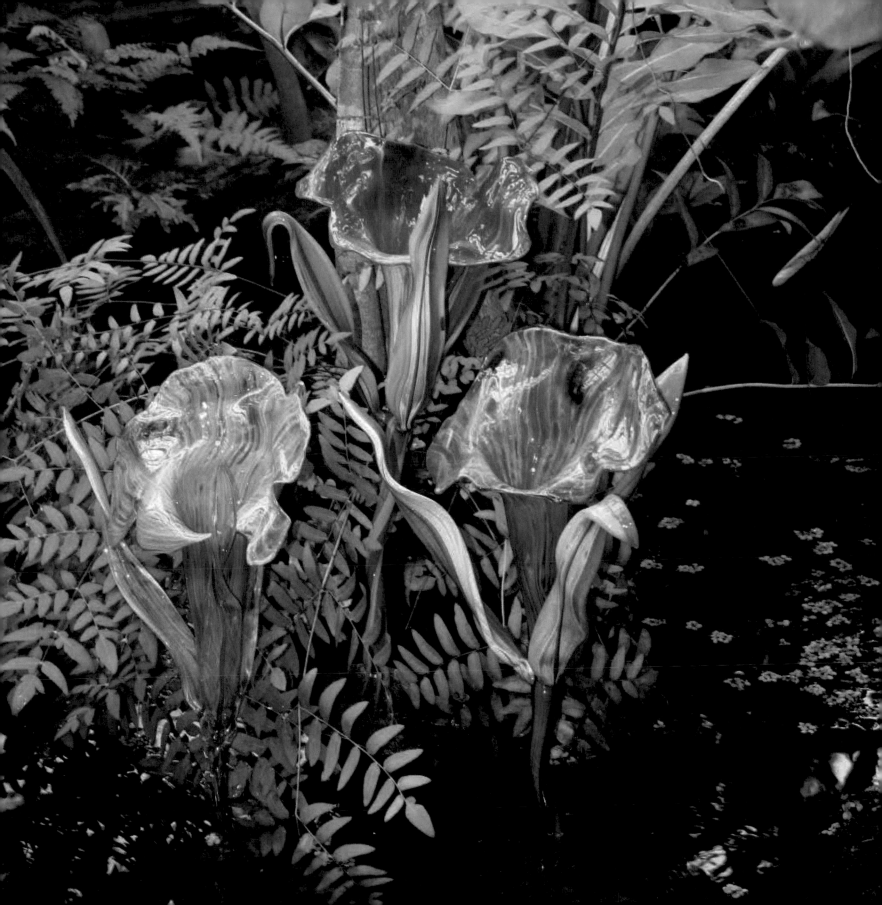

Fräbel Flowers at the Artful
Garden Exhibition of the Atlanta
High Museum in 2006.

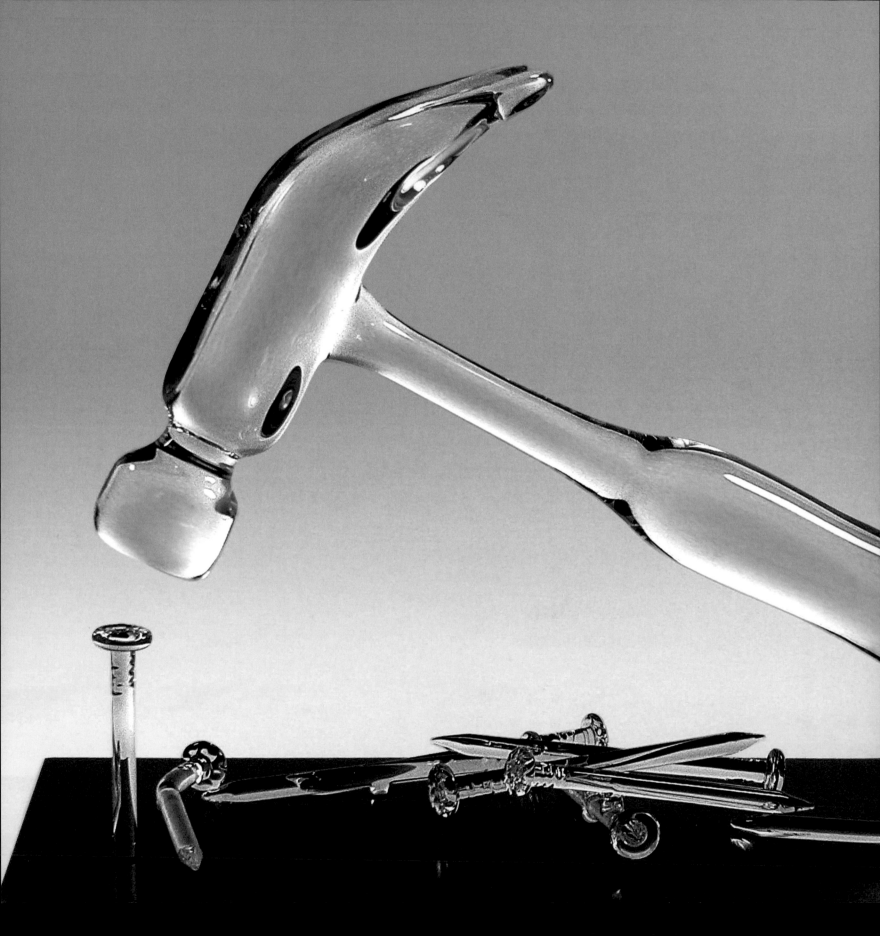

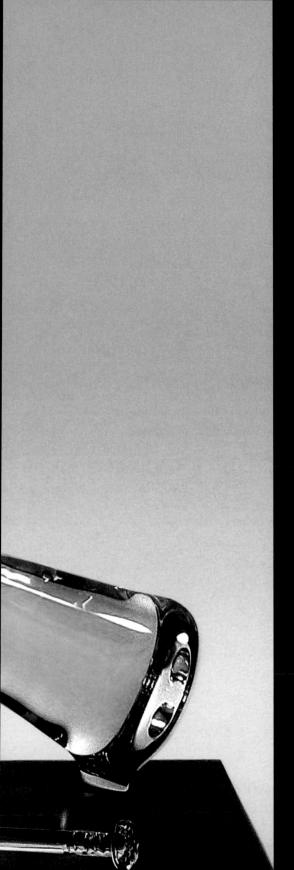

FRÄBEL

EXCELLENCE IN GLASS ART

By Gerrit op de Ese

Left: Fräbel's famous Hammer and Nails sculpture, 1977.

This was the main piece in the New Glass Exhibition that started in 1979 until the early 80's and visited museums around the world. It was sold at Christie's in 1989 and is in the collection of the National Building Museum in Washington D.C.

Distributed by Morgan & Chase Publishing, Inc.

© Gerrit op de Ese, Atlanta, Georgia, U.S.A., 2007

ISBN 0-978-1-93398920-4

Printed in the U.S.A.

Morgan & Chase Publishing, Inc.
Medford, Oregon, U.S.A.

DESIGNED BY
JASON CRIM

Front Cover

"The Cavorting Clowns" by Hans Godo Fräbel, 1987.

This sculpture of Clowns Cavorting around an Absolut Vodka bottle was created in 1987 in a series of Clowns with Absolut Vodka bottles when Hans Godo Fräbel was chosen as an Absolut Vodka artist. The Absolut Vodka Company acquired three of the sculptures created in this series. The one shown on the front cover was utilized in their advertising campaign from 1987 through the early 90's. Hans Godo Fräbel created his first hollow glass clown figure in mid 1960's and has continued to create clown sculptures in different sizes, varying from a few inches to over thirty inches tall.

Back Cover

"The Cavorting Clowns" by Hans Godo Fräbel, 1987.

This is how "The Cavorting Clowns" sculpture was depicted in the "Absolut Fräbel" advertising campaign. Posters, magazine advertisements, and even refrigerator magnets were created using this image. Original advertising outings of the "Absolut Fräbel" campaign are sought after by collectors and actively auctioned around the world.

CONTENTS

Foreword by Philip Rudisill

I met Hans Fräbel in Germany when I was an American Vice Consul at Frankfurt. He was a highly trained and expert maker of scientific instruments in glass at the "lamp" or torch, who happened also to have a penchant for artistic expression. When I left the Foreign Service and returned to Atlanta, I was able to help him land a position as a scientific glassblower at Georgia Tech. He began "playing around" in his free time with some "artsy stuff." The first expressions were small animals, 3 or 4 inches in size, which had marvelous and individual personality. I took some of these little master-pieces to show off his prowess to my colleagues at my work. These small pieces engendered such excitement that I encouraged Hans to make more, which we then sold.

Buoyed by this excitement of my coworkers, Hans began making larger and more significant pieces, traditional work like goblets, nature works in flowers, mythological creatures and abstracts. We looked for some gallery to represent him, but since there was no interest in Atlanta galleries at that time, we decided to open our own gallery, which we did with the backing of Hans' lampwork-ing colleague, Don Lillie. We found available store space and opened The Fräbel Gallery there in November of 1968 with my aunt, Mary Trippe, as manager. We were fortunate in our location being on the main street of Atlanta, Peachtree Road, at a traffic light and with very large show win-dows facing west. The exposure at that location was marvelous. In the afternoon rush hour traffic commuters would stop at the traffic light and could not help but gaze at the brilliant and dazzling display from the interaction of the glass sculptures and the afternoon sun. The gallery was successful from the very beginning.

Very soon Hans stopped scientific work entirely to give free reign to his artistic bent. He began teaching associates to work with him in this very difficult but also very magical medium of hot, lampworked glass. Eventually his hot glass studio engaged ten full time artists.

"In the Middle of the Night" by Hans Godo Fräbel, 1976.

This sculpture of an exaggerated drop of water hanging on a faucet, frozen in time is in the permanent collection of the Smithsonian Institution in Washington D.C.

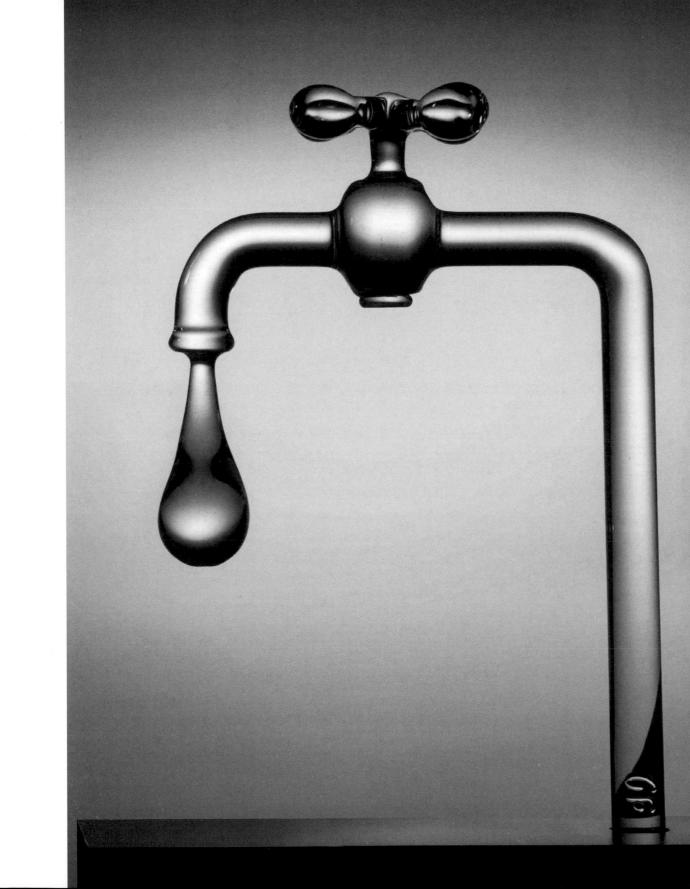

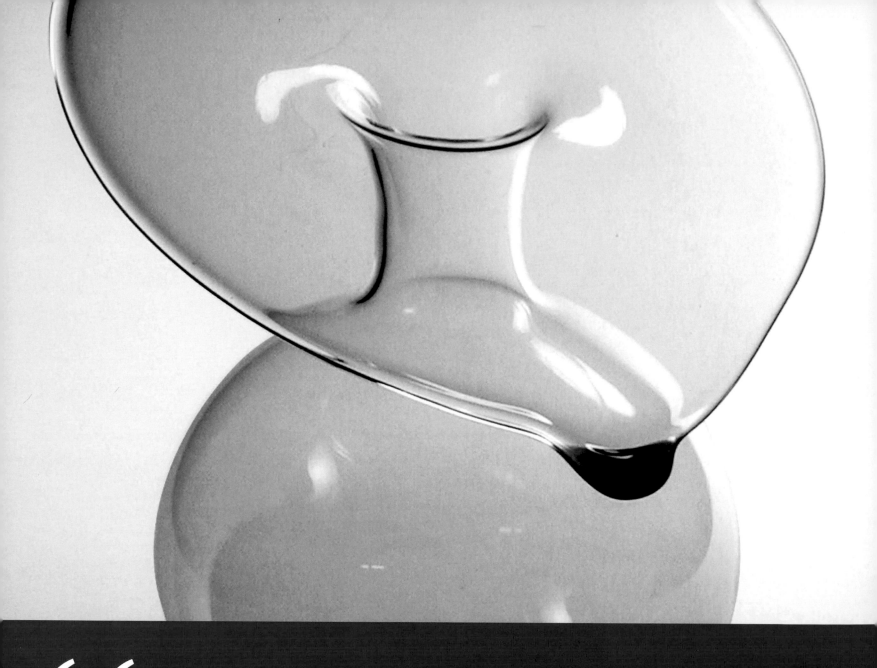

FRÄBEL PRESENTED LAMPWORKING
AS A TRUE ART MEDIUM FOR
THE FIRST TIME IN AMERICA. " "

— ROBERT MICKELSEN

According to Robert Mickelsen (Vetro Magazine, 6/98) the legacy of Hans Godo Fräbel may be summed up in these words:

"[Fräbel] presented lampworking as a true art medium for the first time in America. He specialized in the depiction of everyday objects in glass in unexpected contexts: a sculpture of coat hangers, a row of giant glass nails pounded into a plank and with glass hammer frozen in mid-strike, a faucet with a drop of water suspended forever. Fräbel's innovative approach to lampworking was an inspiration to a generation of lampworked artists, many of whom copied him shamelessly, but all of whom were deeply influenced by him. All across America, young lampworked artists followed Fräbel's example and tried, with varying degrees of success, to emulate his approach."

Even though Fräbel was a native of Germany, we can rightly be proud of him as an American artist for it was here that he first "came out" as a serious glass sculptor. This book seeks to demonstrate the truth of Mickelsen's assertions about the marvelous innovations of this exceptional lampworker and his Studio.

Philip Rudisill, 2007
Managing Director of Fräbel Studios from 1968 until 2004 and close personal friend of Hans Godo Fräbel.

"Blue Teardrop Vase" by Hans Godo Fräbel, 1968.

An original design by Hans Godo Fräbel of a small vase wherein the top transforms into a teardrop. This vase design has remained a classic piece of the Fräbel Studio.

1
History of the Fräbel Studio

History of the Fräbel Studio

Hans Godo Fräbel founded the Fräbel Studio in 1968 to give expression to his then novel concept of sculptural flame worked glass. At that time crystal glass was not considered a serious art medium and artists were not utilizing the beauty and diversity that the techniques of flame worked glass offers to create unique art pieces.

Before the 1960's glass designers would give their design to a factory glass worker, who would then try to create their design in glass. Harvey Littleton and Hans Godo Fräbel were some of the first artists who choose glass as their art medium.

Hans Godo Fräbel was born in Jena, East Germany in 1941. He was the third child in a family with five children. The tumultuous political climate in existence after WWII necessitated a family migration to a small city called Wertheim in West Germany, where Fräbel's father opened a scientific glass factory with a business partner. After moving a few times, the family ended up in Mainz am Rhein, a much larger city in West Germany, where Fräbel's father got a position as a controller at the Jena Glaswerke. At the age of 15, Fräbel did not enjoy school very much and his father then directed him into a "Lehrausbildung Program" (a traineeship) as a scientific glassblower at the prestigious Jena Glaswerke in Mainz, West Germany. Within 3 years, Fräbel received his "Gehilfenbrief," an apprenticeship diploma, showing that he had mastered the trade of scientific glass blowing.

In 1965 he came to the United States and settled in Atlanta. There he obtained a position at the Georgia Institute of Technology in their scientific glass blowing laboratory. During this time, he continued his art studies at Emory University and Georgia State University.

While working at Georgia Tech, Fräbel's creative talents were often sought after by professors and acquaintances alike to create crystal glass sculptures as gifts for friends, partners and business associates. With so many people enjoying the beauty of his glass sculptures, Fräbel felt strengthened to continue his quest to become an artist.

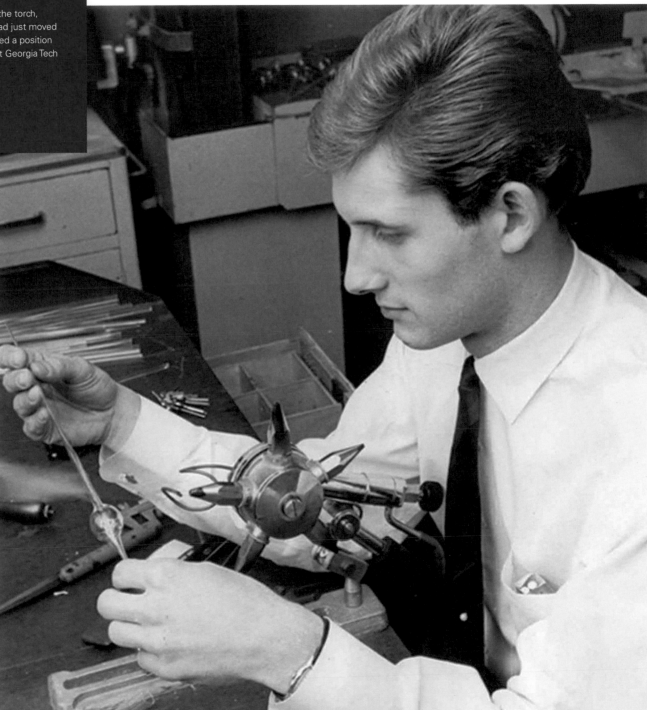

Hans Godo Fräbel behind the torch, 1965. Hans Godo Fräbel had just moved from Germany and assumed a position as scientific glassblower at Georgia Tech in Atlanta, Georgia.

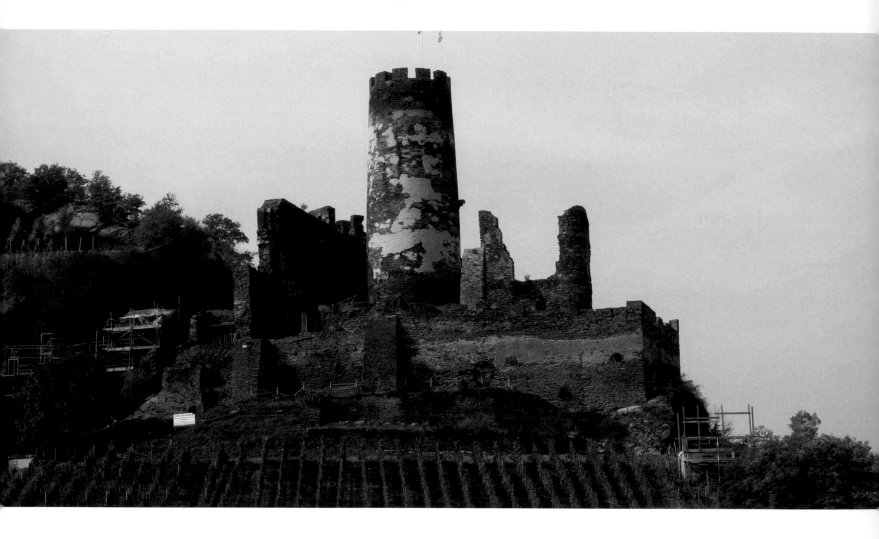

Left

One of the many beautiful castles on the
Rhine River in Germany, only minutes
from Mainz am Rhein, where Hans Godo
Fräbel lived as a young adult.

Right

"David and Goliath" by Hans Godo Fräbel,
1970.

Depiction of the biblical epic of David and
Goliath recreated in borosilicate glass
in the early days of Hans Godo Fräbel's
career as a glass artist.

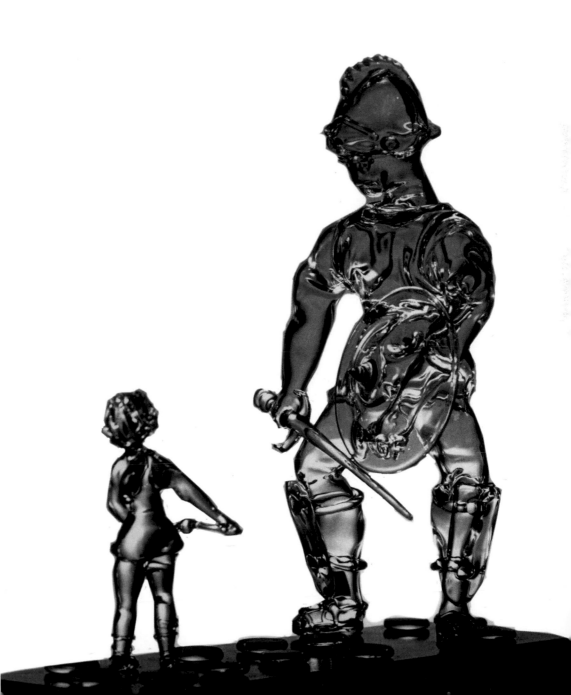

In 1968, Fräbel decided to set up his own glass studio in Atlanta, Georgia. Over the next 40 years, he would follow in accordance with the European tradition of apprentice and master: As the master artist he would pass his skills on to a handpicked group of apprentices, who after many years of training would become master artists in their own right.

Although Fräbel's art received much attention in the United States, his international breakthrough as a glass artist was not until 1979 when his pop art sculpture "Hammer and Nails" was utilized as the feature piece of the New Glass Art Exhibition. For the next several years, the exhibition toured the world visiting museums in numerous major cities. This international exhibition recognized Hans Godo Fräbel as one of the founding fathers of modern torch work in the world of art.

Paul Gardner, late curator of Ceramics and Glass at the Smithsonian Museum, attributed the beginning of the modern lampworking studio art movement to leaders like Fräbel in The Collectors Encyclopedia of Antiques.

> "Fräbel's work embodies a host of mixed expressions, which find their voice in the enormous diversity of his art. His rapid exhaustion of any given subject matter and his sudden interest in a new field have given him the reputation of impetuosity in the field of torch worked glass art, which has perfected his unusual precision at the torch. This aptitude for excellence was developed through the rigorous technique of the German master craftsman system, thus earning him the nickname of Machine Hands."

Over the years Fräbel's reputation as a master in glass art has spread worldwide beyond the glass community. Fräbel art pieces can be found in public and private collections in over 80 countries worldwide. Some of the more illustrious collectors of Fräbel glass art are Queen Elizabeth II, Emperor Akihito and Empress Michiko of Japan, current and former heads of governments such as Jimmy Carter, Ronald Reagan, Margaret Thatcher, Anwar Sadat as well as museums in London, Paris, Tokyo, Dresden, Valencia, Corning, San Francisco, New York and Washington D.C.

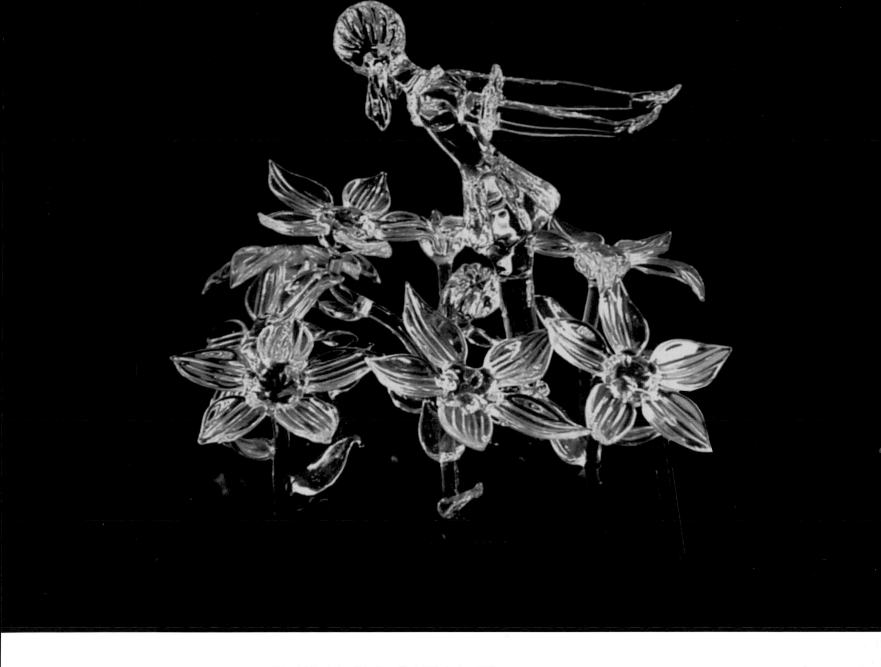

"Alice in Wonderland" by Hans Godo Fräbel, circa 1969.

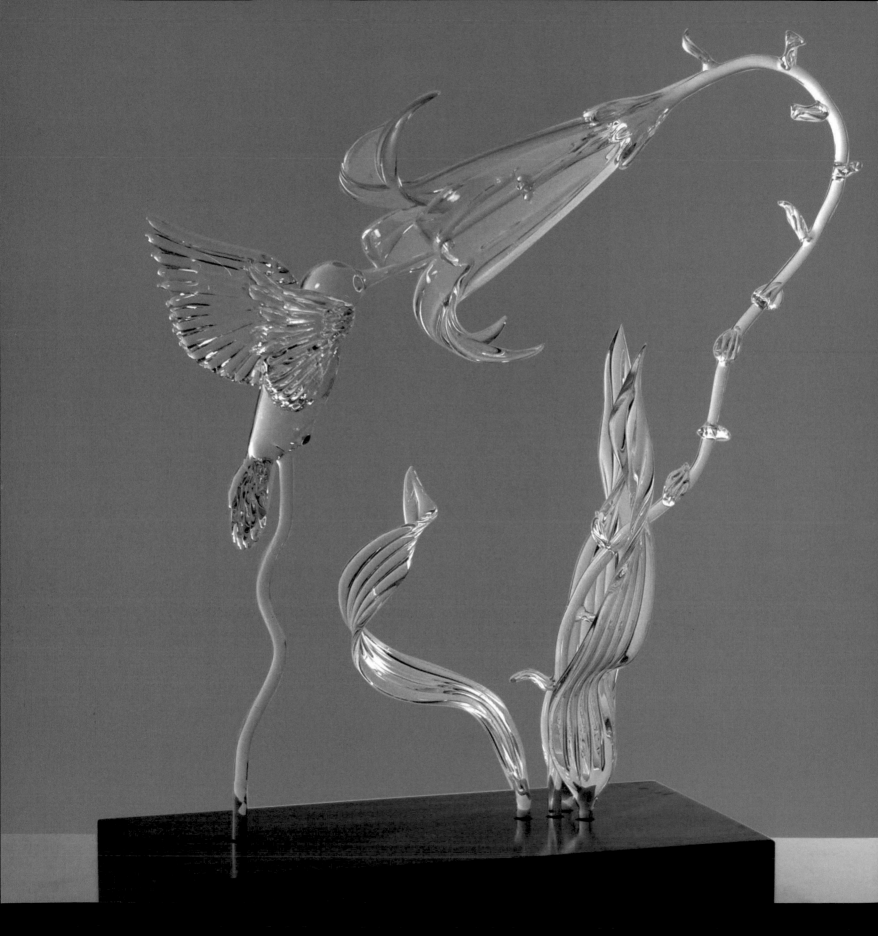

Left

"Hummingbird and Lily" by Hans Godo Fräbel, 1973.

An original design by Hans Godo Fräbel of a Hummingbird and a Lily. This is the original Studio design, which has undergone several redesigns.

Right

"Wolves Vase" by Hans Godo Fräbel, circa 1968.

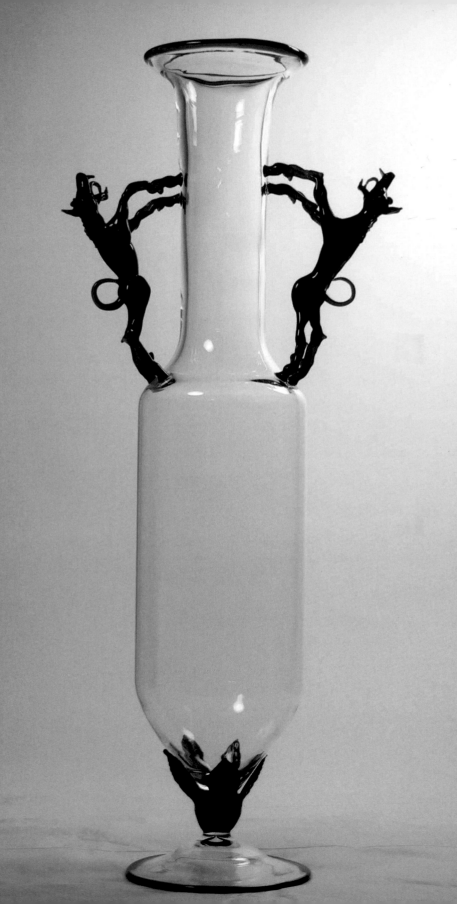

Two of the most famous trademarks of the Fräbel name are the "Hammer and Nails" sculpture from the New Glass Art Exhibition which is currently housed in Washington D.C.'s National Building Museum and was featured in both LIFE magazine and the New York Times; and the playful, cavorting clowns which received worldwide recognition with the Absolut Vodka advertising campaign in the late 80's and early 90's. Hans Godo Fräbel was the first glass artist honored with the title of Absolut Artist. Other famous artists that were chosen as Absolut Artist are Andy Warhol and Keith Haring.

Until the mid nineties, the Fräbel Studio created art pieces almost exclusively in clear borosilicate, a strong, brilliant crystal that is resistant to scratches and which if broken can usually be restored without a trace of damage. "In the mid 1990's, technological advances in Borosilicate glass allowed the artists of the Fräbel Studio to use color glass. Since that time, color has formed an increasingly important part of the Fräbel repertoire. Other techniques the Studio employs are sandblasting and painting. Sandblasting gives the sculpture a frosted, highlighted appearance, which is an interesting optical illusion. This optical illusion is produced by the human eye, which cannot handle the diffractions of the fine indentations in the glass. The indentations in the glass reflect all colors of light from its surface, giving it a whitish tint.

The work of the Fräbel Studio has become so well known that its location is a source of entertainment and education and is on the itinerary of many regional tour guides. The Studio has accepted students to work directly with Fräbel artists to learn about glass and glass art.

Studio sculptures of the Fräbel Studio are embossed with the trademarked "FS," which stands for "Fräbel Studio," wherever space permits on the piece itself. The Fräbel name and the initials of the artist who executed the design are engraved into the mounting peg, which holds the sculpture steady in its base. The executing artist sculpts the piece entirely by hand, based on the model created by the designer. These Studio sculptures are called Multiple Originals because each sculpture is uniquely created and molds are never used. The vast majority of original Fräbel Studio models are designed by Hans Godo Fräbel himself.

One-of-a-kind Fräbel sculptures are signed with "GF," which stands for Godo Fräbel. These sculptures are one-of-a-kind exclusives or limited editions. Although an original study model has been created, it will never leave the Fräbel Studio. The mounting peg bears the year of its creation.

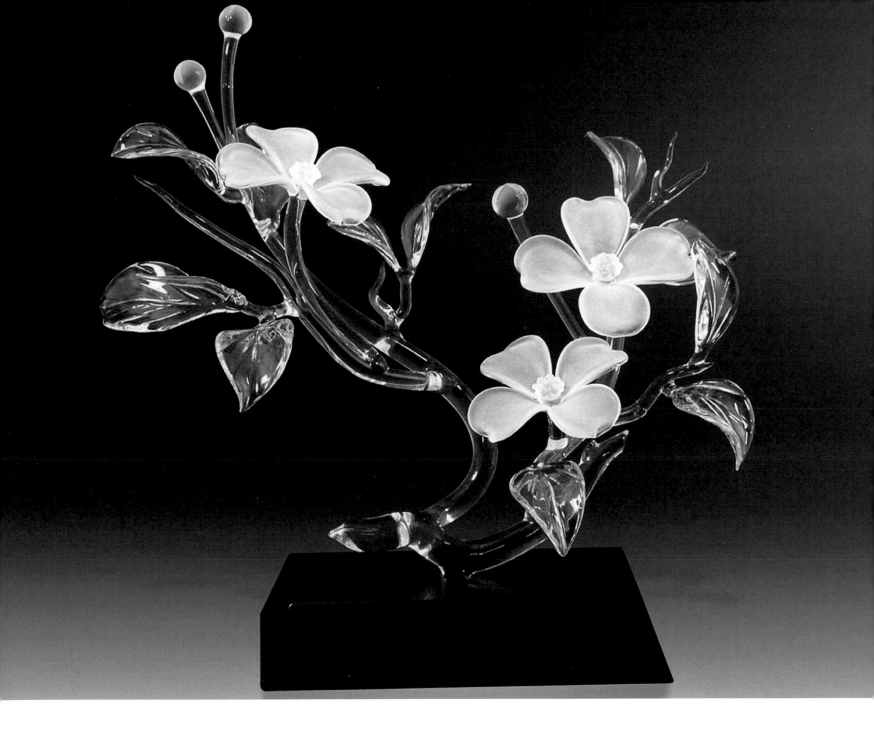

The Dogwood

The Dogwood, Atlanta's flower, is a popular studio sculpture of the Fräbel Studio.
Over the years, the Fräbel Studio has created many different compositions of this beautiful
flower. This picture shows a Dogwood composition from 2006.

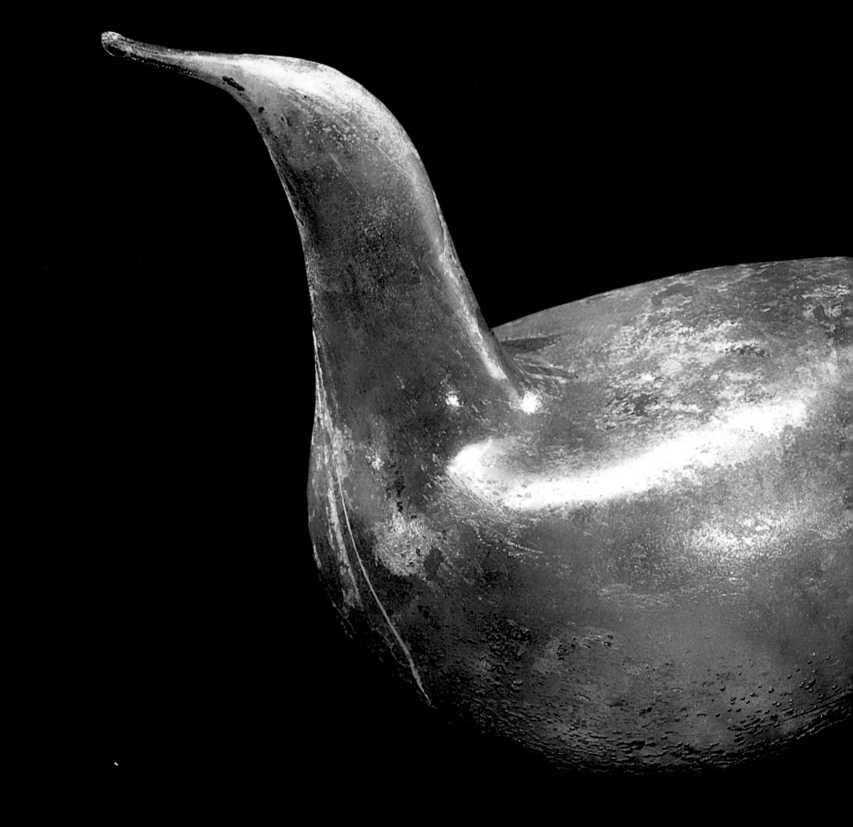

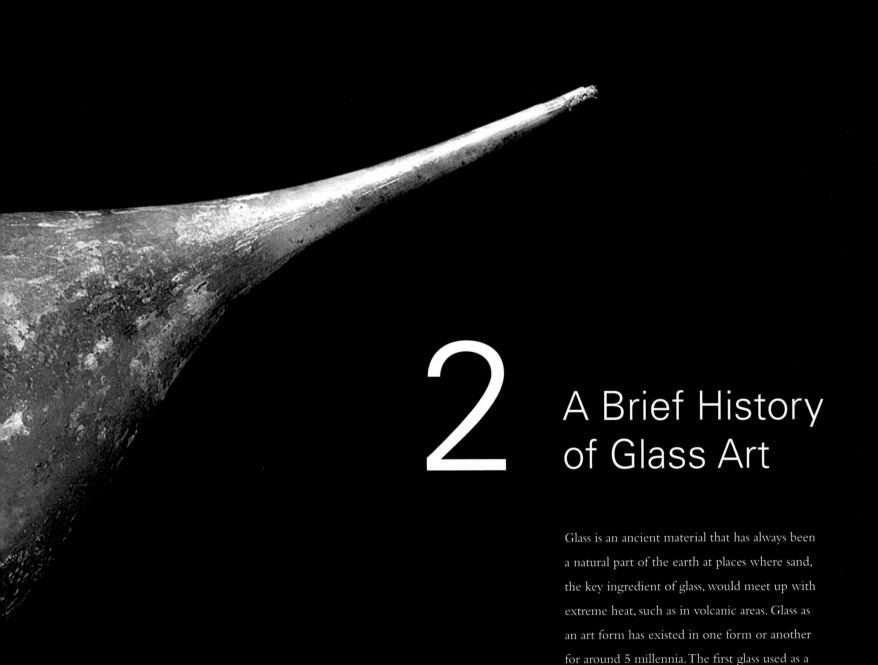

2 A Brief History of Glass Art

Glass is an ancient material that has always been a natural part of the earth at places where sand, the key ingredient of glass, would meet up with extreme heat, such as in volcanic areas. Glass as an art form has existed in one form or another for around 5 millennia. The first glass used as a tool or ornamentation was obsidian, a natural glass byproduct of volcanoes.

The Discovery of Glass

There are several theories about how glass was first created and manipulated by man. Although most historians today think of these theories as legends, Pliny the Elder's paradigm (23 A.D.-79 A.D.) is so popular that it deserves mentioning.

> "Merchants on a moored merchant ship laden with nitrum were preparing their meal on a beach. They did not have stones to prop up their pots, so they used lumps of nitrum from the ship. This mineral fused with the sands of the shore where upon streams of a new translucent liquid flowed, resulting in the discovery of glass."

Historians believe that the invention of glass was more deliberate than the previously mentioned legend. The Phoenicians, a group of people living in Mesopotamia, the current Syria, Iraq, Turkey and Israel, used glass to glaze ceramic objects such as cups, vases, plates, etc. as early as 3000 B.C. Since they liked the properties and appearance of glass, they kept developing this glazing material until they were able to create items entirely from glass. From here furnace structures developed in Mesopotamia, as early as 2700 B.C. Glass products discovered include glass beads and seals.

Vessel Shaped like a Bird (Chapter Spread)

Roman Empire; Northern Italy or Rhineland, 1st century A.D. Transparent light blue glass; blown.
Collection of The Corning Museum of Glass, Corning, NY.

Below

"Burning Bush" by Hans Godo Fräbel,
circa 1996.

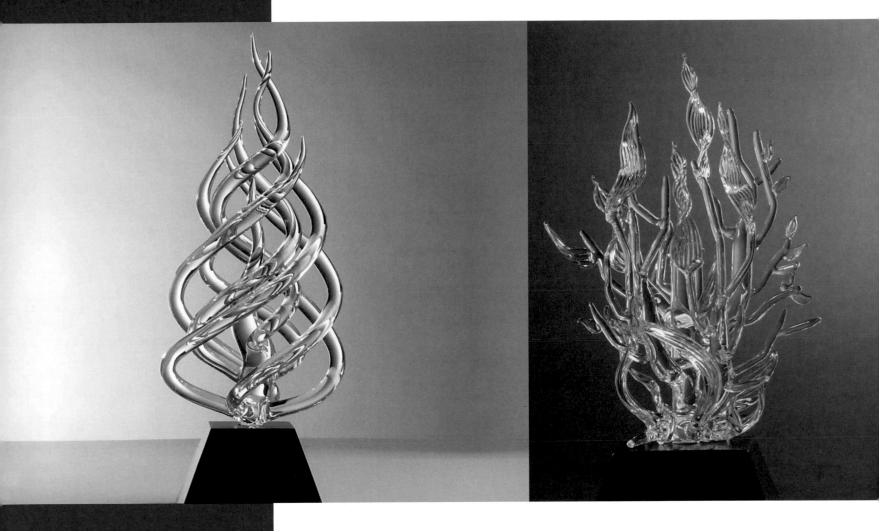

Left

Hsankeyf, Turkey
Small town on the banks of the Tigris,
once a mighty city of Ancient Mesopotamia.

Far Right

"Burning Bush" by Hans Godo Fräbel,
circa 1970.

Studio design based on the biblical epic
of the burning bush. The Burning Bush
sculpture has since undergone several
redesigns.

29

Left

Hsankeyf, Turkey Small town on
the banks of the Tigris, once a mighty
city of Ancient Mesopotamia.

Right

Portrait of King Amenhotep II
Egypt about 1450-1400 B.C.
Deep blue glass: cast

Collection of The Corning Museum
of Glass, Corning, NY.

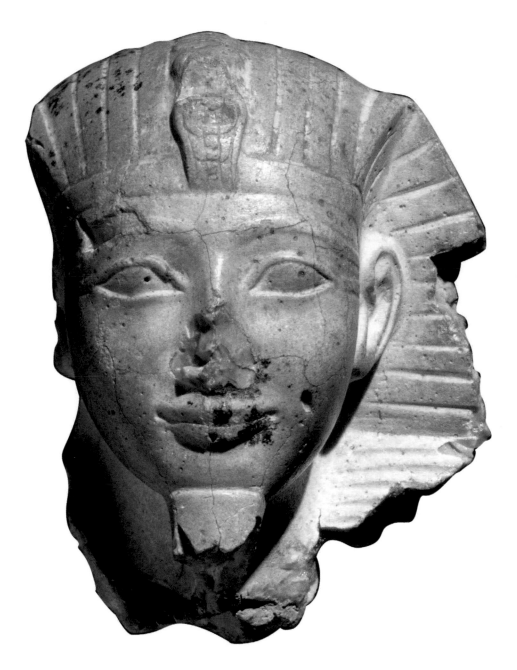

Glass became a popular art form in jewelry to mimic gemstones in colors not found in nature. These glass gemstones were even more expensive than the real products due to the complexity of making them. This is indicated in one of the world's oldest living texts, the Bible. "Gold and glass cannot equal it, neither shall it be exchanged for jewels of fine gold." Job 28:17

Natural glass is not clear at all but instead has a faint greenish or bluish tinge from the copper and iron oxides in the sand. Today, imperfections are filtered out of the glass and lead oxide or other additives are used to turn the glass clear.

Glass eventually evolved into utilitarian use for items such as small vases, cups, bowls and other every-day objects. Oftentimes, sand particles would remain in the finished product due to the imperfection of the refining process.

By the 1st century B.C. the art of glassblowing had been discovered in the far eastern reaches of the Mediterranean. This new technique allowed the glass workers to create even more extravagant and creative forms with which to explore their craft.

It is commonly believed that the first glass blowing tubes, called blowpipes, were created from clay. This would have made glass working extremely uncomfortable as it is impossible to create a long enough pipe fashioned from clay to protect the artist from the 1000 degree Fahrenheit hot glass. Soon, metal blowpipes were created to greatly reduce the threat of harm and allowed the artist to create larger and heavier pieces.

Bottom Left

Egyptian Phoenician glass vases from
around 1st Century B.C.

Right

Phoenician Terracotta Vase, from around
1st Century B.C.

A duck-shaped terracotta vase from
National Museum, Bardo, Tunisia.

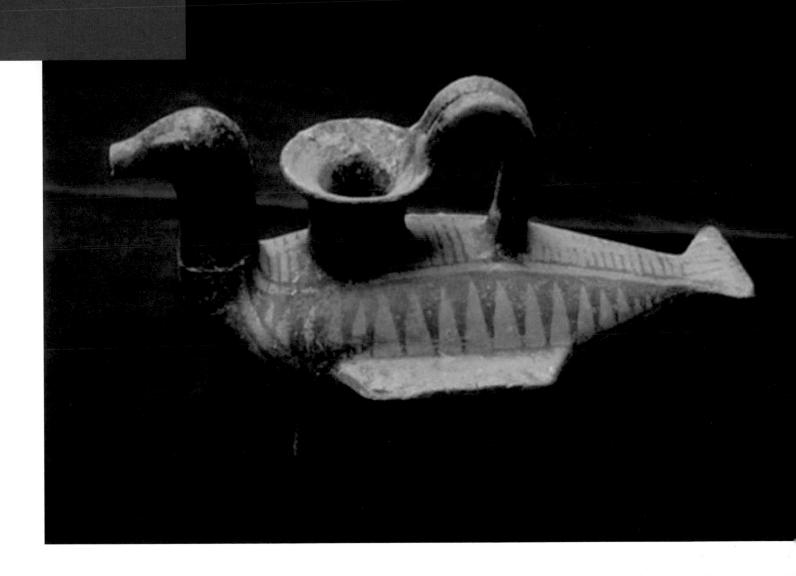

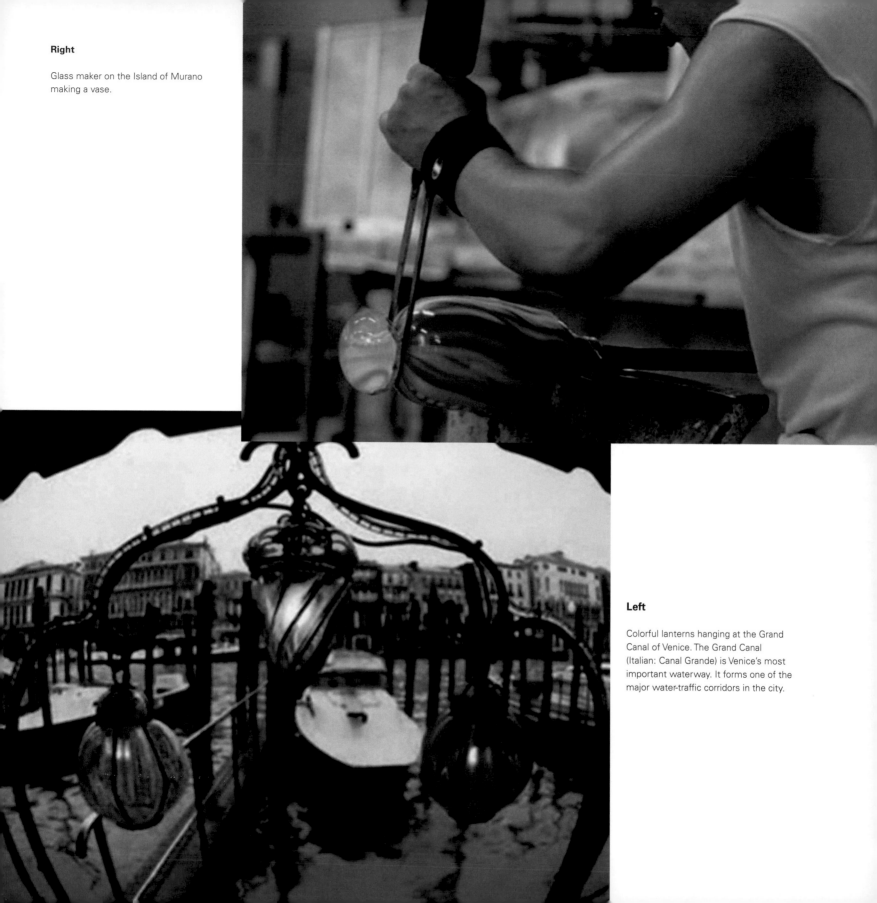

Right

Glass maker on the Island of Murano making a vase.

Left

Colorful lanterns hanging at the Grand Canal of Venice. The Grand Canal (Italian: Canal Grande) is Venice's most important waterway. It forms one of the major water-traffic corridors in the city.

Below

A glassblower in an old fashioned
workshop, depicting how glassblowing was
executed in the 1st Century B.C.

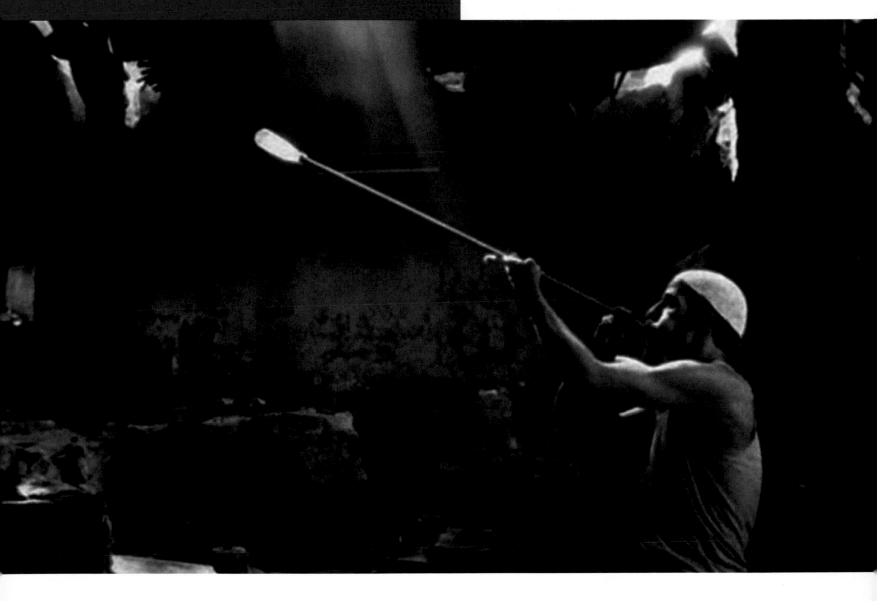

Venetian and Murano Glass

By the 8th century, Venice had become the glass capital of the world. At that time, Venice traded heavily with Eastern Mediterranean areas, North Africa and the Middle East. These influences brought new techniques and ideas to the artisans of Venice and they used these to create exceptional pieces of art. The conquest of Constantinople in 1204 during the Fourth Crusade is believed to have been an important event that brought Venice additional glassblowing techniques for the glass industry.

By the 13th century the glass artists had combined all their knowledge into unique and proprietary production skills. Venetian glassmaking became the leading source for fine glass in Europe and a major source of trading income for the Republic of Venice. In 1291, the government of Venice banned glass furnaces from the central islands, relocating them to Murano, a small group of islands about two miles north of Venice. Until recently, most historians have assumed that the order was a result of fear that the fires of the glass furnaces might create a raging inferno among the largely wooden structures of crowded Venice. However, it has been plausibly suggested that the move was made in order to hide the master glassblowers and prevent the many foreigners who visited the city from gaining the valuable glassmaking techniques. Essentially, the glassblowers became virtual prisoners, isolated from contact with anyone who might divulge their production secrets to potential competitors abroad. It is for this reason that Venetian glass is now known as Murano glass.

The glass production in Murano was so important for the Venetian economy that the government went so far as to forbid glassworkers from traveling outside of Murano. There were even claims, though unsubstantiated, of Murano glassworkers who left to work in other parts of Europe, who were assassinated when they refused to return to Murano.

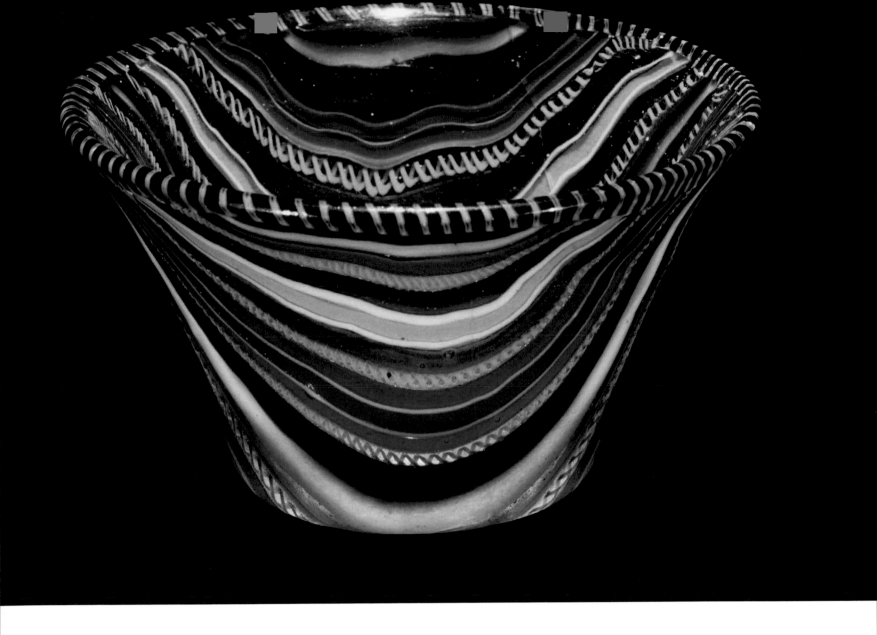

Ribbon Glass Cup

Roman Empire, about 25 B.C.-50 A.D. Preformed canes fused into three
identical units, then sagged over former mold, fire-polished, upper parts lathe-turned

Collection of The Corning Museum of Glass, Corning, NY.

Excellence in Glass Art

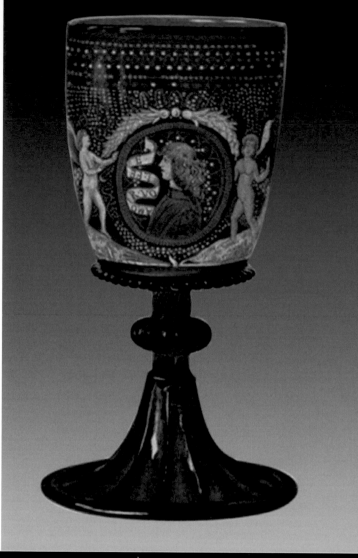

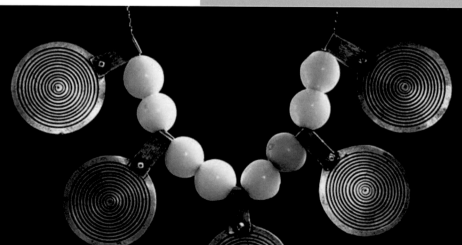

Top Left

Venetian Nineteenth century
enameled glass chalice.

Right

Goblet with Grotesque Decoration
Venice, about 1500-1525
Colorless glass, mold and free-blown,
tooled, applied, gilt and enameled

Collection of The Corning Museum of
Glass, Corning, NY.

Bottom Left

Berber Necklace with Venetian glass
and trade beads.

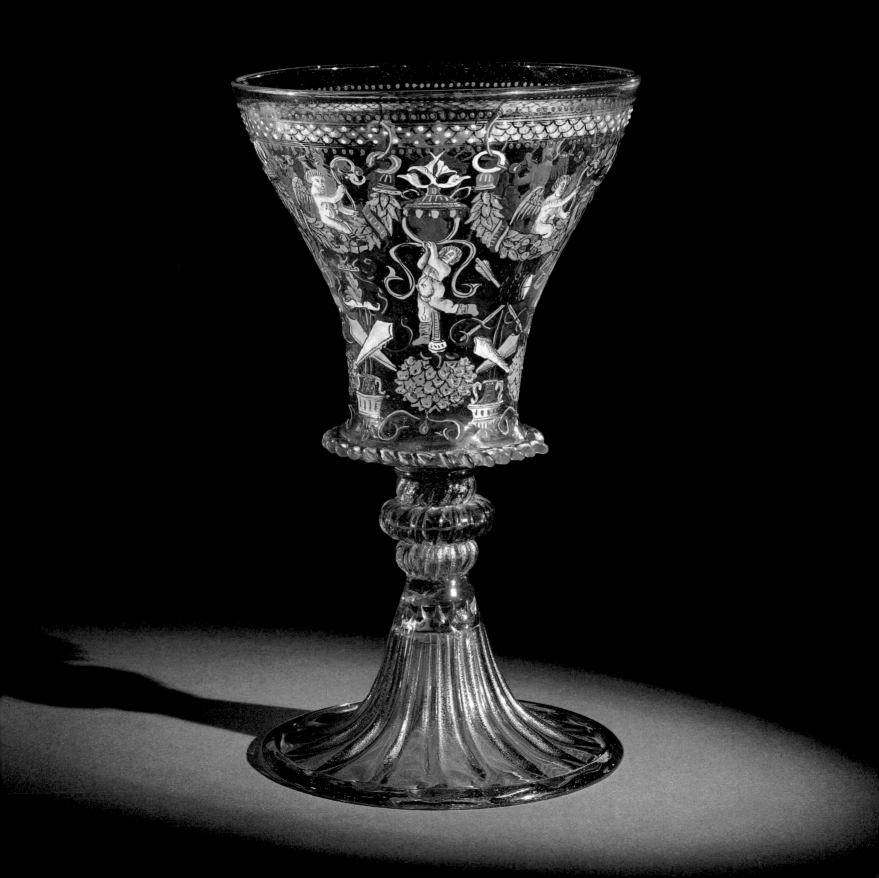

Most of the glass from this period, though luxurious, was still utilitarian. Mirrors, for example, were major revenue producers, but beautiful and complicated decorative objects were produced as well, often exhibiting complex new techniques developed by Murano's extraordinary artisans.

By the 15th century, Murano glass artisans started experimenting with different additives to create a clear type of glass, called "cristallo," from which the English word "crystal" is derived.

The "Cristallo" glass that the Venetians created was an Italian soda glass and was as clear as they could get their glass. Usually it was still a pale yellow since it was difficult to make glass completely transparent. It was made with a plant called "Barilla" which grows in the salt marshes. The Barilla lowered the melting temperature of the glass, enabling it to be formed into myriad shapes. It was thin and brittle and could only be engraved using a diamond point. This was the popular type of glass in the 15th and 16th century and heavily exported until lead crystal was invented in England. Today's soda glass is created with chemical soda, which has eliminated the need for the expensive plant ingredients in glassmaking.

By the 16th century serious competition began to emerge, particularly in France and Moravia (a region located in the current Czech Republic). At the same time, changing trade routes began to undermine Venice's strategic trading advantages. As a result, the decline in Venice's general economical importance was mirrored by the gradual, long-term decline of its glass industry on Murano.

It was not until 500 years later, between 1860 and 1960, that Murano's glass art underwent a remarkable revival, which brought Murano's glass producing firms back to leadership in the production of decorative glass objects.

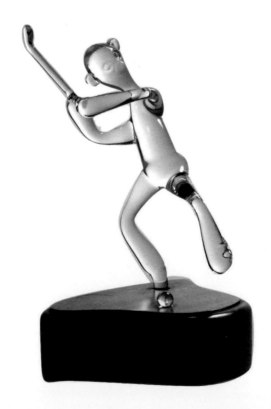

Left

"Abstract Golfer", Hans Godo Fräbel, 1969.

Right

"Oven", Hans Godo Fräbel, circa 1968.

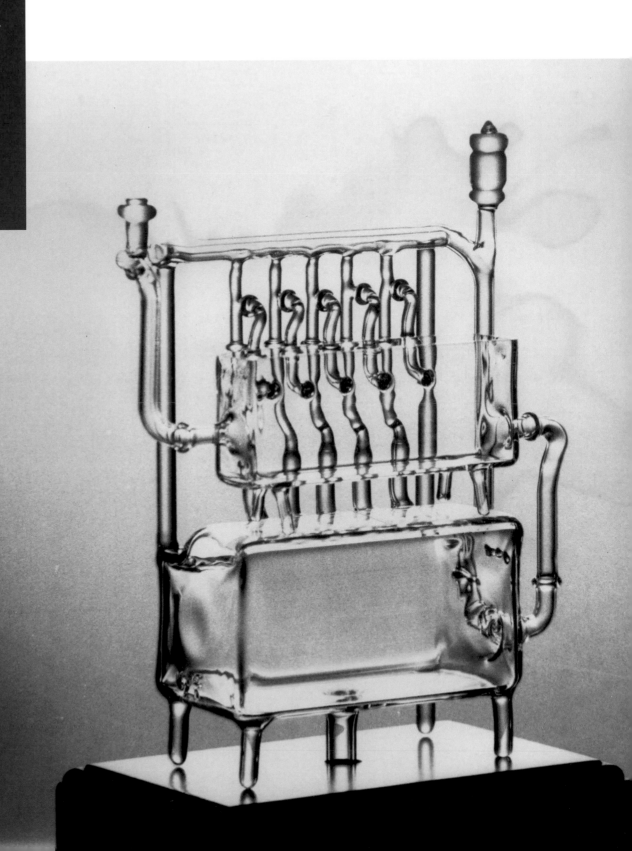

Left

Window in the late gothic Saint Peter's Cathedral (1507-1508), depicting the Pentecost, the Virgin and the Disciples.

Right

A Venetian glass bowl recovered from an ancient Venetian merchant ship near the Adriatic island of Gnalic. The ship may have been the Gagliana which disappeared near the isle of Gnalic in 1583.

German Glass Art

In the 12th century, a glass technique that had not seen much popularity became revitalized when a German monk named Theophilus, who was also an artist and a metalsmith, created beautiful stained glass windows. Theophilus wrote a text titled "On Diverse Arts" where he described how he carefully studied glaziers and glass painters at work in order to provide detailed instructions for creating windows of "inestimable beauty."

A window's pictorial image is created by arranging different pieces of colored glass over a design drawn on a piece of board. If fine details such as shadows or outlines are required, the artist paints them on the glass with black paint.

To assemble the window, pieces of colored and painted glass are laid out on the design board, with the edges of each piece fitted into H-shaped strips of lead known as cames. These cames are soldered to one another such that the panel is secure. When a panel is completed, putty is inserted between the glass and the lead cames for waterproofing. The entire composition is then stabilized with an iron frame called an armature and mounted in the window.

Another important contribution to glass and glass art that came from Germany is the invention of the first borosilicate glass by the Jena Glasswerke in 1887, the company where Fräbel learned his trade as a scientific glassblower.

The Morgan Cup

Roman Empire, probably Italy, 1st century. Transparent blue glass, cased with translucent white glass; blown, cased, wheel-cut and engraved.

Collection of The Corning Museum of Glass, Corning, NY.

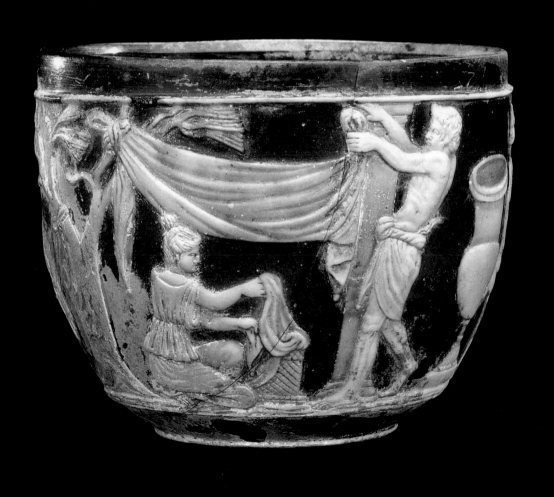

Excellence in Glass Art

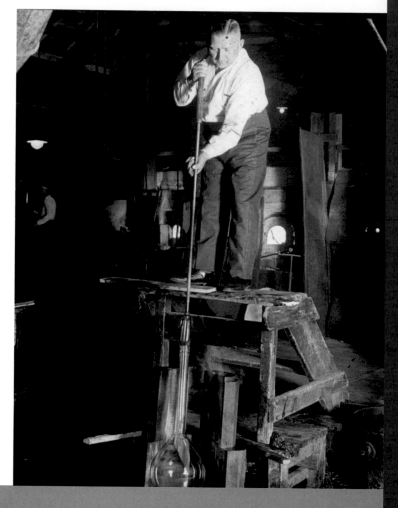

Top Left

Glass worker at the Jena Glaswerke
around 1920's in Jena, Germany
using the force of gravity to create the
right shape.

Right

Glass worker at the Jena Glasswerke
around 1930's.

Bottom Left

The birth city of Hans Godo Fräbel, Jena in
Germany, 2006.

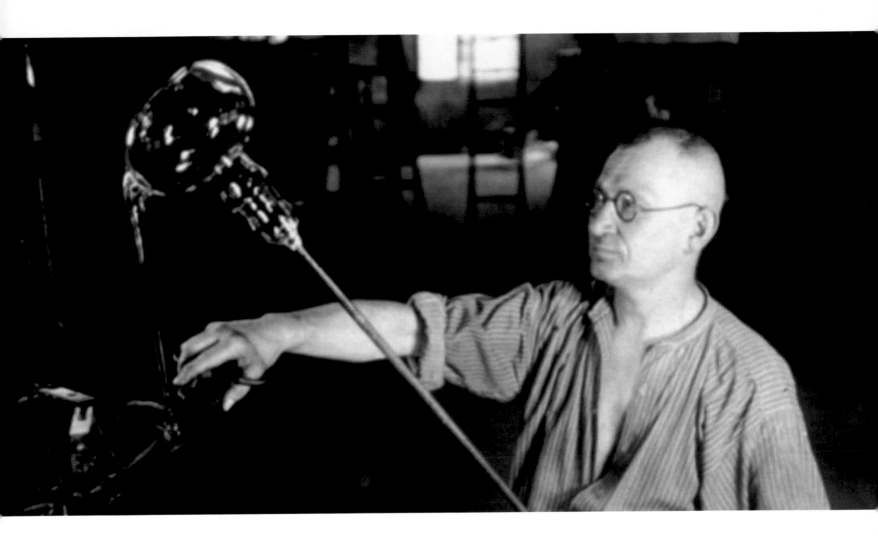

In 1884, Dr. Otto Schott founded the glass production company "Schott und Genossen," together with Dr. Ernst Abbe and Carl Zeiss in Jena, Germany. Later this company was renamed "Jenaer Glaswerke," after the area in which it was located. Dr. Schott invented the first type of Borosilicate glass, also called "Jenaer Glas," in 1887. This new type of glass had the ability to withstand extremely high temperatures, enabling it to be used in gas and petroleum lights. This invention was the major breakthrough for "Jenaer Glaswerke," and in that same year the company made its first profit. From its inception until 1909, Jenaer Glaswerke sold over 30 million gas and petroleum light glasses.

The property to withstand both high and low temperatures made Borosilicate the ideal material for the creation of glass instruments for scientific and chemical purposes. Because of this invention, Jenaer Glaswerke became one of the largest suppliers of scientific glass instruments in the world.

This Borosilicate glass had another advantage: It could be heated numerous times, which made it a perfect material from which glass sculptures could be created, as the artists of the Fräbel Studio have done.

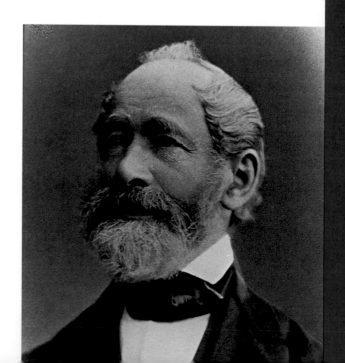

Right

Dr. Otto Schott (December 17, 1851
– August 27, 1935), one of the founding
partners of Schott und Genossen and
the inventor of Borosilicate glass, the
material utilized by the Fräbel Studio to
create their pieces of art.

Schott was born in Witten, Germany and
was a Chemist and Glass Technologist.
He was the son of a window glass maker,
Simon Schott. The company that bears his
name would develop into a large multina-
tional, headquartered in Mainz, Germany.

The invention of Borosilicate glass in 1887
was the big breakthrough for Schott and
his company. Borosilicate has unique
properties compared to regular glass. It is
extremely heat resistant, can withstand
thermal shock (sudden temperature chang-
es) and is highly resistant to chemicals.

Left

Carl Zeiss (September 11, 1816
– December 3, 1888) was an optician
best known for the company he founded
named Zeiss. Zeiss made many notable
contributions to the lens manufactur-
ing industry, which led to the modern
production of lenses we have today. The
company also manufactured high qual-
ity lenses for cameras; something the
company is still famous for today. Raised
in Weimar, Germany, he was a notable
lens maker in the 1840's when he cre-
ated high quality lenses that were "wide
open", which means that they had a
very large aperture range that allowed for
very clear images. Zeiss' lenses were
used in microscopes and later in cameras.
He was one of the founding fathers of
Schott und Genossen.

The Invention of Crystal Glass

As described in an earlier chapter, it was the Venetians who created the first type of crystal, which they called "cristallo." Crystal glass refers to a clear type of glass, independent of the additives used to get the clarity of the glass. The Venetians initially used a plant called Barilla to get the glass clear and malleable. This first crystal glass gained huge popularity and became a successful export product for the Venetians in the 15th and 16th century.

In the middle of the 16th century several leading glassblowers moved from Murano to London, where they found the favor of Queen Elizabeth I who enjoyed the glass pieces they created. The Venetian influence and the Queen's support were the basis for the discovery of lead glass in the following century.

Four centuries later, England is ruled by Queen Elizabeth II, who besides sharing her predecessor's name, also shares her passion for glass. In her extensive art collection, one can find an especially for her created Fräbel sculpture.

In 1673, George Ravenscroft established his own glass factory in London. Shortly thereafter, in 1675, he patented a process for making "flint glass" or "lead crystal" by adding lead oxide to Venetian glass. Ravenscroft discovered that the addition of lead oxide to glass during the melting process improved the clarity of the glass, while lowering the melting point, therefore, making it easier to work with. Such problems as the introduction of a bluish tinge and "crizzling" of the glass were encountered in the early stages of his work. Increasing the lead content in the crystal reduced or eliminated these issues. He continued experimenting with the chemical composition of glass, and eventually eliminated the imperfections. The practice of cutting the lead crystal glass became popular shortly after the invention of lead crystal. In the 18th century, England saw a boom in glass factory production; however, a government excise tax on glass dampened profits and factory manufacturers tried to escape this tax by moving their factories to Ireland. During this period, Ireland became the new center for production of lead crystal in Great Britain. Crystal glass factories elsewhere in Europe thrived throughout the 19th century in France, Sweden, Austria and the Czech Republic.

Queen Elizabeth I

Queen Elizabeth I (September 7, 1533 – March 24, 1603) was one of the best loved monarchs and one of the most admired rulers of all time. When she came to power in 1558, England was an impoverished country torn apart by religious squabbles. When she died at Richmond Palace, England was one of the most powerful and prosperous countries in the world, which is why her reign is often referred to as The Golden Age of English history.

Besides a great ruler, she also had a keen eye for art and was one of the first well-known glass art collectors.

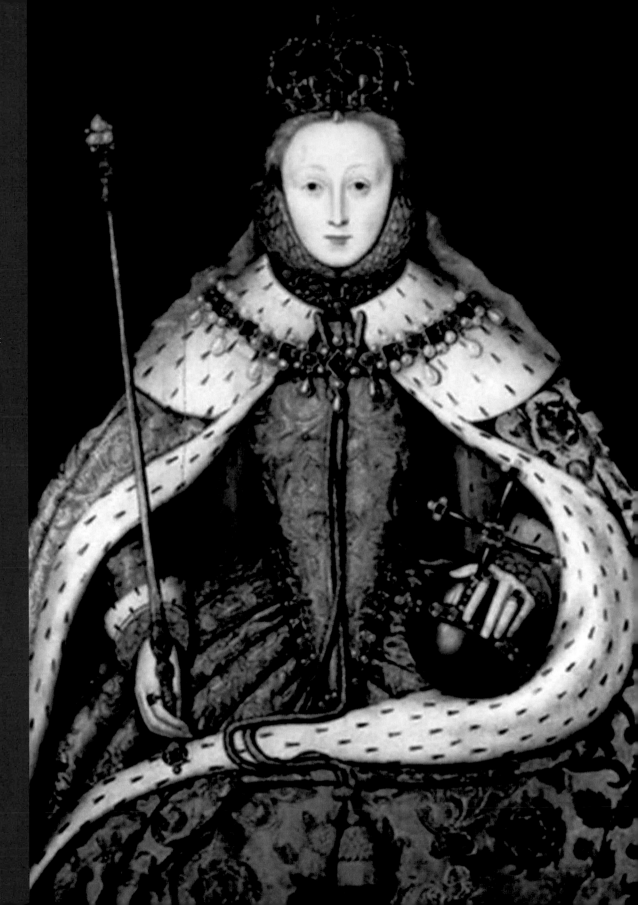

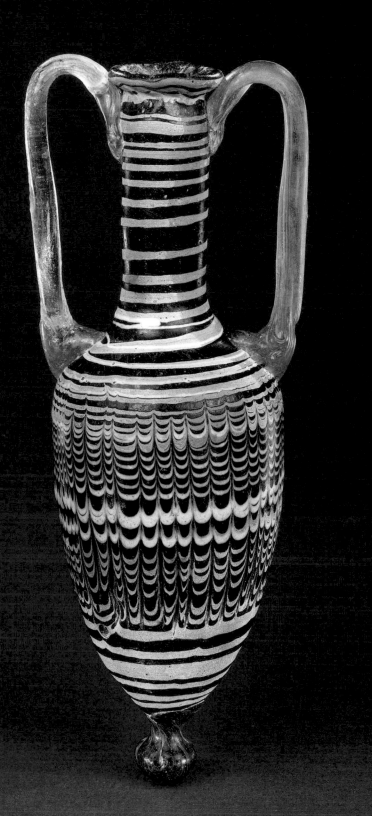

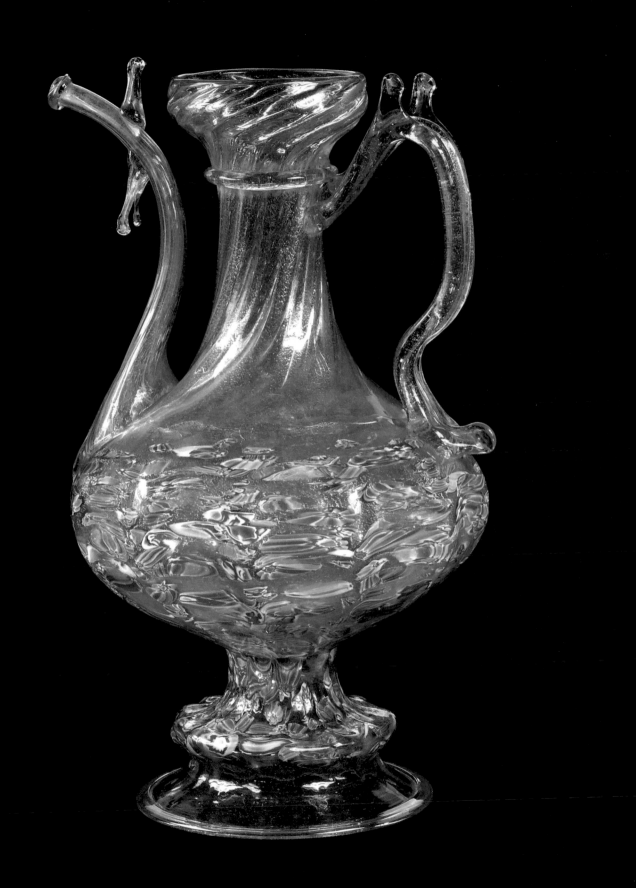

New Uses for Glass

In the 20th century innovative uses for glass were invented. Today medical scientists use a glasslike material for artificial dental fixtures and bones. An advantage to using glass as opposed to mercury or metal is that glass is nontoxic and rarely rejected by the human body.

Recently, medical breakthroughs have been achieved in the United States by utilizing small glass radio-active spheres to treat liver cancer. Microscopically small glass spheres with a diameter measuring less than a follicle of hair are radiated and brought into the liver where they get "stuck." Millions of these glass spheres give off high levels of radiation that extend no further than a few millimeters. One benefit of this type of radiation treatment to destroy cancerous cells is that a higher level of local radiation can be applied directly to an area with minimal risk to patients.

Until the 20th century, glass objects were were typically produced in glass factories where skilled workers fabricated the pieces, based on the drawings of designers. In the 1960's technological advances made it easier and more comfortable to work and manipulate glass. Artists, such as Hans Godo Fräbel and Harvey Littleton quickly discovered this new and enormous potential for glass. Independent from each other, both began to experiment artistically with glass in small group settings; consequently, the studio glass movement was born.

Ennion Ewer.

Roman Empire, Syria or Palestine, probably, 30-69 A.D. Transparent amber glass, body and neck blown in three-part mold, rim reworked, handle applied.

Collection of The Corning Museum of Glass, Corning, NY.

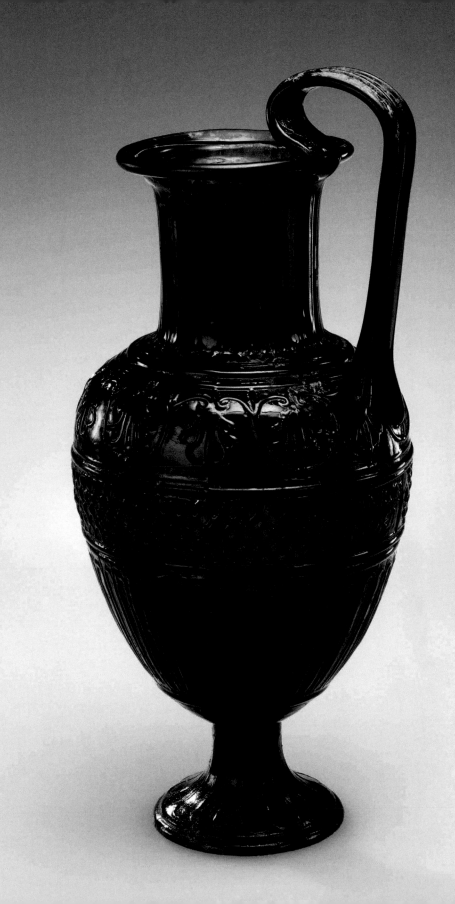

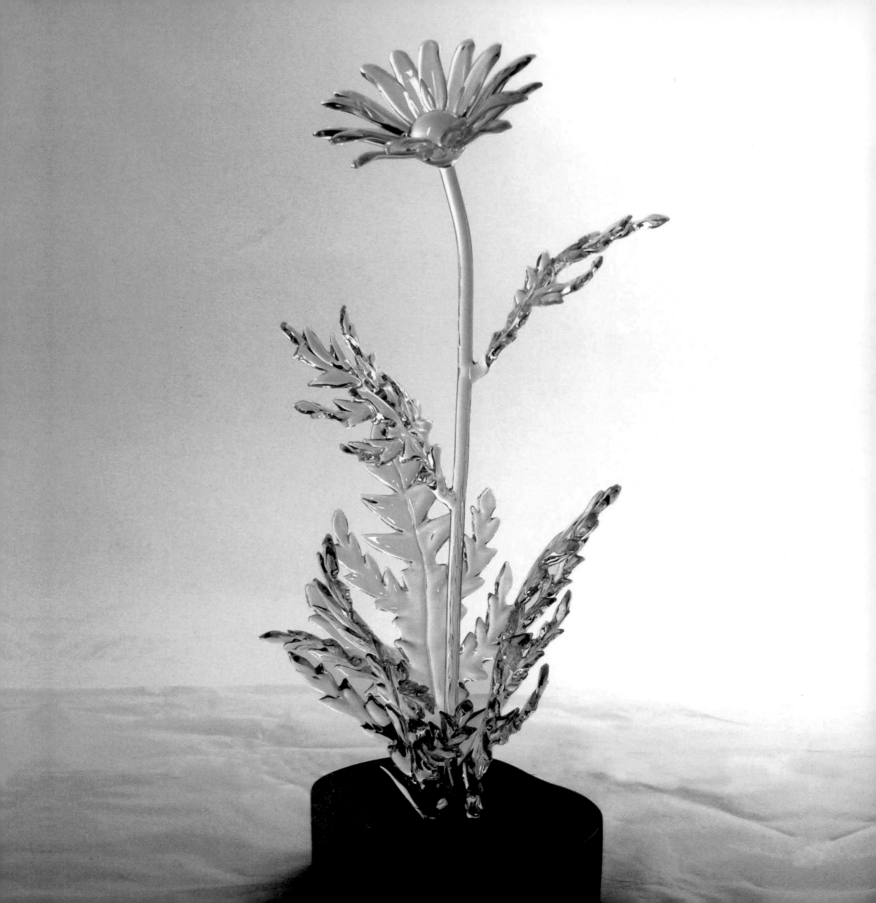

Left

"Fieldflower" by Hans Godo Fräbel,
circa 1970.

Right

"Ostrich" by Hans Godo Fräbel, Limited
Edition of 150, 1980.

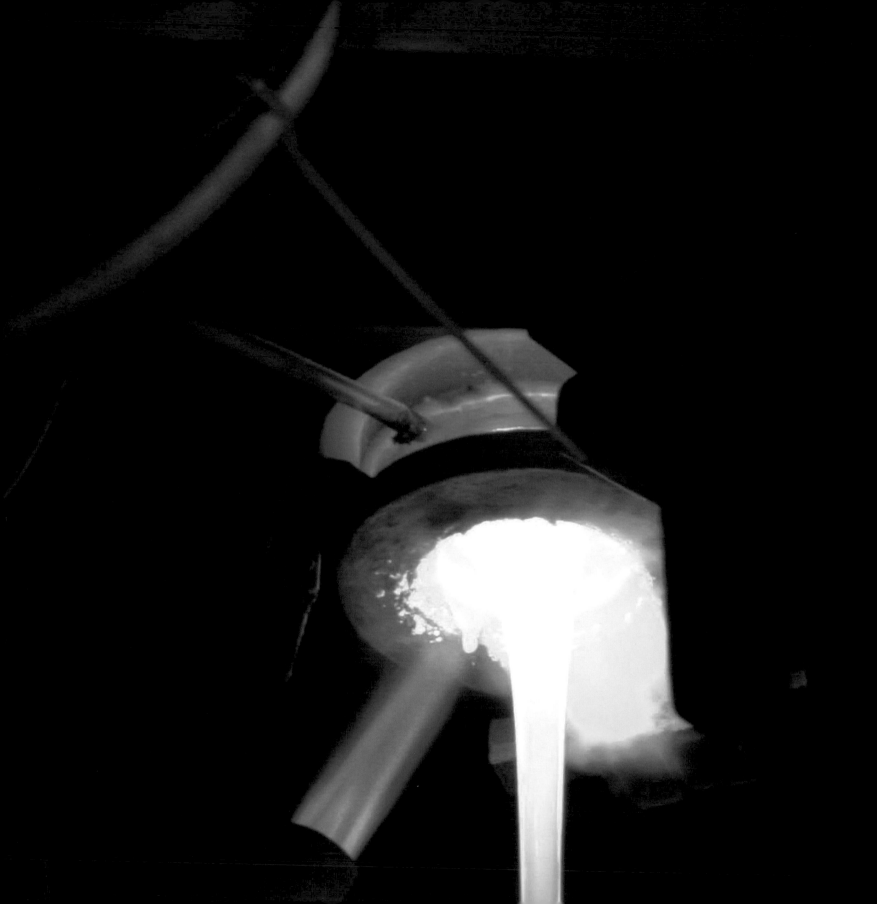

3 Glassmaking Process

Glass is a hard substance, usually brittle and transparent, composed chiefly of silicates and an alkali fused at high temperatures. The most incredible fact about glass is that although it appears to be a solid, it is--chemically speaking--an extremely thick liquid. Anything made of glass will eventually, over the course of hundreds, thousands or millions of years, slowly "drip" and sag in. This phenomenon can be seen on old windows where the glass has begun to pool near the base.

Most types of glass are a mixture of silica obtained from beds of fine sand or from pulverized sandstone. In order for glass to be melted into various shapes, substances—such as a form of soda, or for finer glass, potash—are added to lower the melting point. Lime is often included as a stabilizer.

The addition of foreign substances to glass alters its properties. A metal oxide such as lead will lend brilliance and weight. Boron will increase thermal and electrical resistance. Barium will increase the refractive index, which is necessary when the glass is to be used for optical objects. Cerium will absorb infrared rays. Metallic oxides will add color and manganese will remove color.

Left

The purest white silica is found deep under the ground in the Bohemia area of Czech. This silica mine has been the source of silica used in the clearest crystal that has been produced in Bohemia since the 1930's.

Right

Fine pristine white silica is the main ingredient for the crystal and glass utilized by the Fräbel Studio.

Above

The silica is mixed with other ingredients to create the basis for Fräbel's borosilicate and brought on this belt to the furnace.

Right

At the bottom of the furnace is where the glass is poured out into perfectly shaped rods onto an over 100 yard long line of metal rollers to slowly cool the glass, after which it is cut in the proper lengths.

The processes of glassmaking have essentially remained the same since its inception. The materials are melted and mixed together at high temperatures in seasoned fireclay containers, boiled down, skimmed, and cooled several hundred degrees. The molten glass is then poured into molds and pressed or blown--with or without the use of molds--or is drawn.

To color the glass, powdered metals are added to the molten mixture. Molten glass can be blown into a sausage shape and then slit on one side before being flattened into a sheet. It can also be spun with a pontil iron into a round sheet called a crown.

Left

To prevent scratching the glass rods are placed on another line, where each rod will be handled and packed individually, so that the artists of the Fräbel Studio will receive only the most perfect borosilicate glass for their sculptures.

Right

A scientific glassblower at Schott in Mainz creates a complex cooling device that will be used in chemical and medical laboratories around the world. This is similar to the scientific instruments Hans Godo Fräbel was trained to make when he was a scientific glassblower at Schott in Mainz in the 1950's.

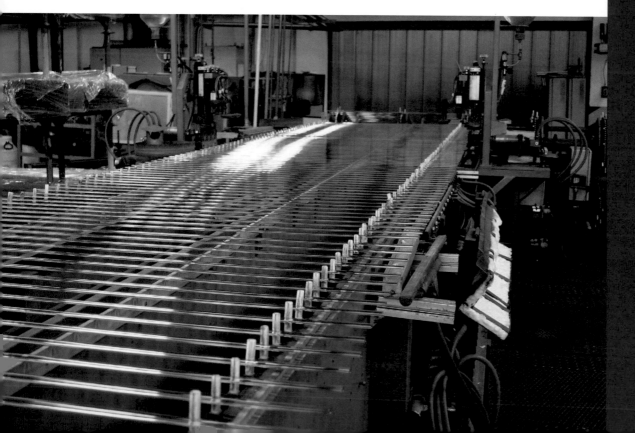

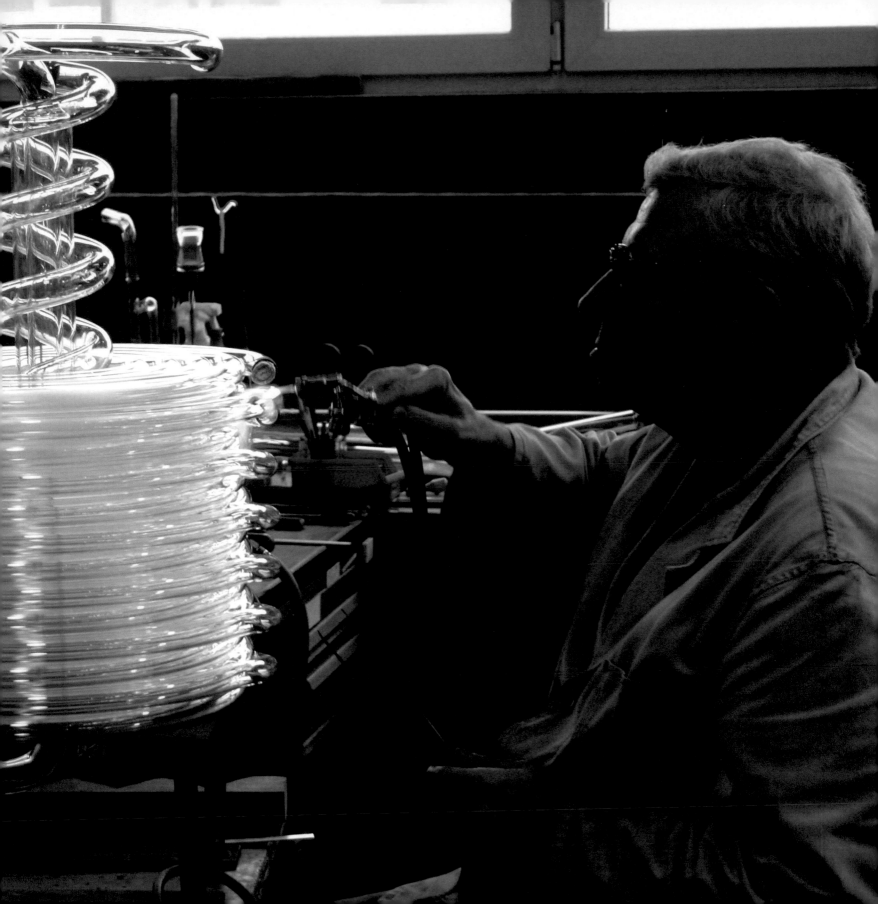

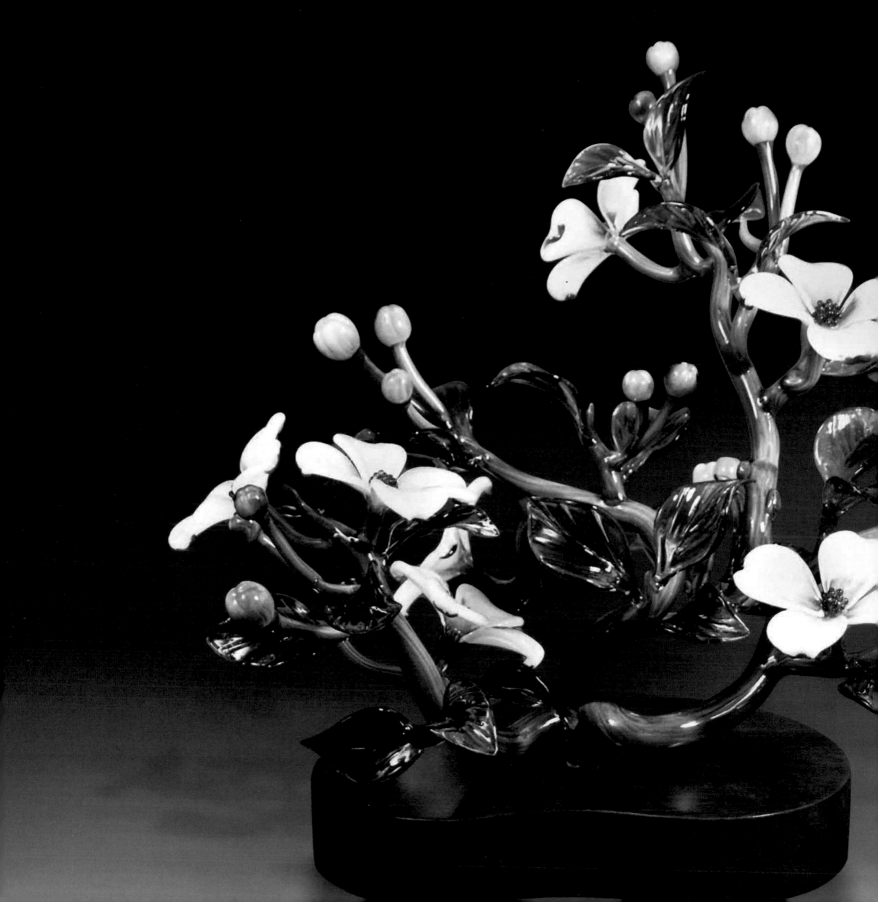

4 The Art of Fräbel Glass Sculpting

Hans Godo Fräbel has perfected the art of glass sculpting by combining ancient glassworking techniques with modern ones that allow him and other Fräbel artists to create the most extraordinary pieces of art.

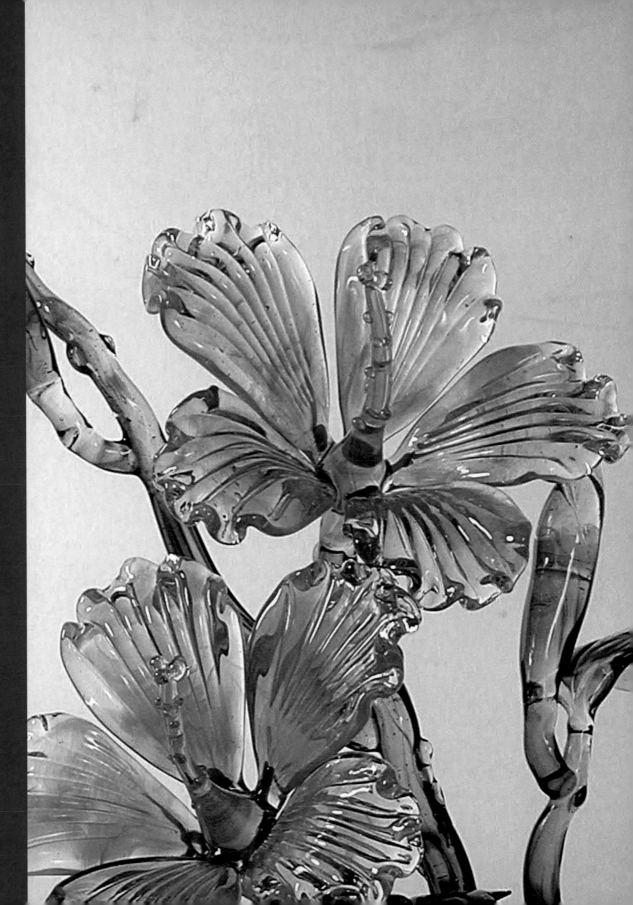

Left

Drawing of a special commissioned
Hibiscus flower sculpture, 2004.

Right

Finished glass sculpture of a Hibiscus
flower, 2004.

Solid Glass Sculptures

The creation of a solid glass sculpture begins with clear glass rods that are carefully protected to prevent scratching. Glass rods come in numerous sizes, shapes and colors. Perfectly round glass rods, measuring from 1/16" (2 mm) to 1½" (40 mm) in diameter, are most frequently used.

Other shapes of glass rods that are used are hollow tubes (for hollow glass art) and flattened glass pieces, all of which vary in size, depending on the glass sculpture the artist is trying to create.

First, the glass sculptor determines which type and size of glass rod or rods are required. To show each of the steps in detail, we will trace the creation of a large 3 blossom Fräbel dogwood flower.

For this dogwood flower sculpture, the Fräbel artist will begin by making the petals for the dogwood blossom out of a 4' long, 3/8" diameter boron crystal rod. The rod is visually inspected for any imperfections, such as air bubbles or scratches. It will then be cut into shorter pieces for ease of handling.

One end is heated and softened in a small oxygen and gas flame (temperature of glass goes to about 2,500°F) and a small ball is formed. During this softening, the rod must be constantly--at the same speed--rotated by hand, since the glass, which when hot turns into a liquid, will droop, due to the earth's gravity, instead of forming a consistent round ball.

When the right size is achieved, the ball is flattened with a tweezer-like paddle into a disk. Rills will form on the surface due to the texture of the paddle. These are removed by reheating the flattened glass disk for a short period.

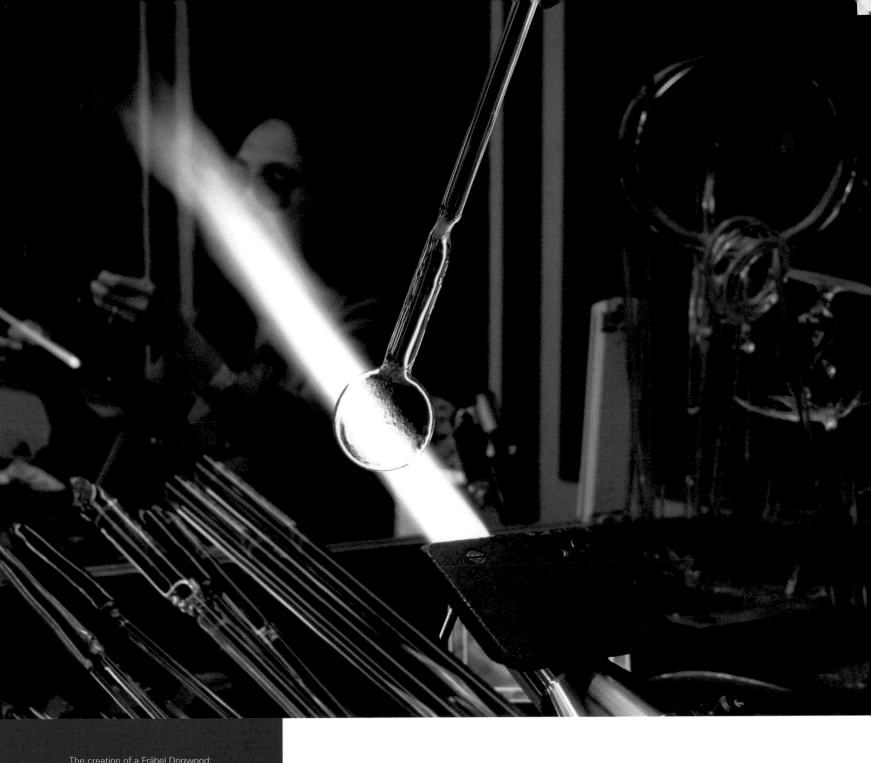

The creation of a Fräbel Dogwood:
Gather glass and create a small sphere.

Next the artist attaches a thin rod to the upper part of the glass disk by heating both the tip of the thin rod and the upper portion of the disk.

The upper portion of the disk is heated and the disk is pulled and stretched into a teardrop shape. Then the disk is reheated and allowed to droop slightly into a desired curve.

The 3/8" rod is removed and the petal's ends are rounded by using the 3/8" rod to sculpt it. A small dimple is formed in the end of the petal with a small hand tool. A pair of tweezers is used to hold the petal in order to disconnect the holding rod by melting it off. This completes the first petal of a dogwood blossom. The artist repeats these steps three more times to create the four petals needed for one dogwood blossom.

The stamen of a blossom is formed by heating a smaller diameter rod and touching it repeatedly with a very thin rod, leaving little "bumps" at the top. Then both the petals and stamen rod are heated until they become cherry red, at which point they can be joined together. The dogwood blossom is now complete.

Next the artist heats and bends a 3/8" boron glass rod to craft a branch shape. Sub-branches are added in the same way and then joined to the main branch.

The artist then makes the leaves, which are formed in a similar manner to the dogwood petals and are attached to the branch.

The dogwood blossoms are connected to the branch by heating the blossom (held by the tweezers) and the branch. Then a short glass peg is connected to mount the sculpture into a handmade black wooden base.

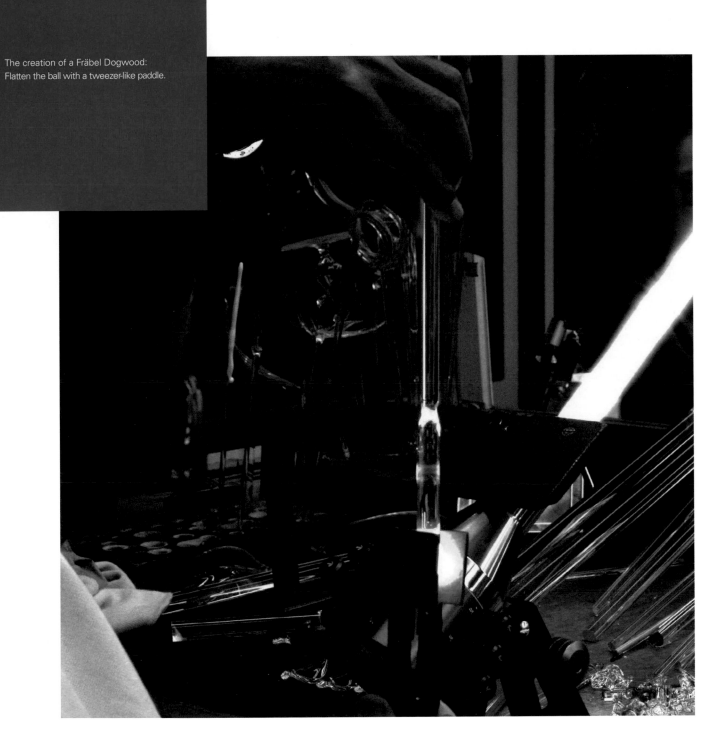

The creation of a Fräbel Dogwood:
Flatten the ball with a tweezer-like paddle.

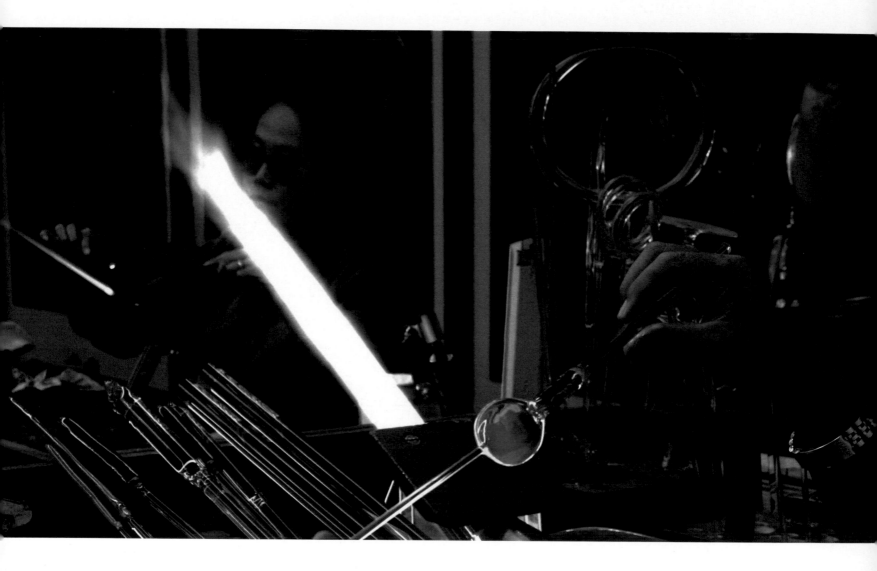

Left

The creation of a Fräbel Dogwood:
Pull the thin rod up a bit, so the Dogwood leaf will receive a natural bending.

Below

The creation of a Fräbel Dogwood:
Attach another piece of glass and stretch the glass, while allowing gravity
to pull down the sides.

Below

The creation of a Fräbel Dogwood:
Remove the leaf from the thick rod, leaving it only
connected to the thin glass rod.

Right

The creation of a Fräbel Dogwood:
Carefully tap the thin rod, so the Dogwood leaf breaks off.

Bottom Right

The creation of a Fräbel Dogwood:
Fuse the 4 Dogwood leaves to the stem.

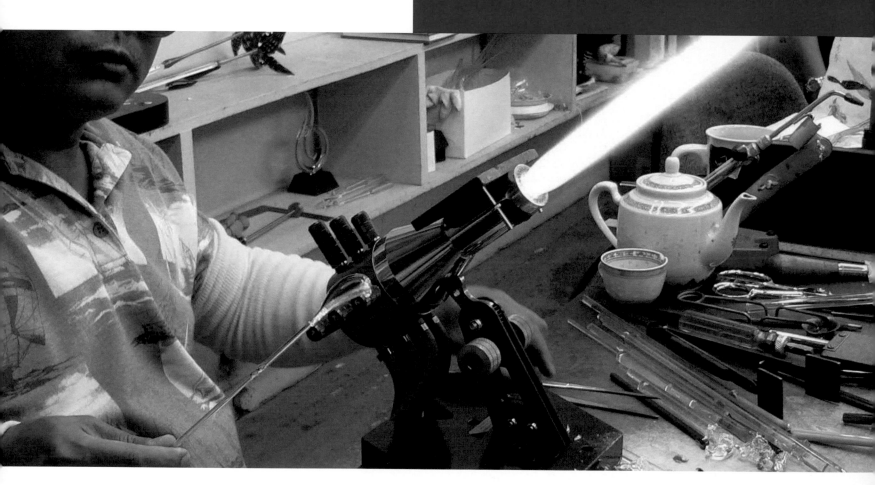

All newly created Fräbel crystal sculptures go through an annealing oven. Enormous stresses have built up in the dogwood sculpture, due to uneven heating in the flame, which would eventually cause it to break. To remove these stresses, the sculpture is put into an annealing oven and raised to a "relaxing" temperature of approximately 1,200°F and then slowly cooled at the same rate, thus removing the stresses.

After the annealing process, the dogwood blossoms may be frosted, to get an opaque finish, giving the petals a whitish look. The opaque finish is an interesting optical illusion. The glass is subjected to a high pressure stream of microscopic, abrasive particles, often referred to as sandblasting, which create microscopically small fractures in the glass (like facets of a cut gem). These small fractures diffuse the light in such a way that it appears whitish. Whenever washed, the fractures are smoothed over with water, so the glass looks clear until dry.

Finally, after the sculpture is carefully inspected for quality of craftsmanship, the Fräbel name and the initials of the artist are embedded into the peg of the sculpture.

Left

The creation of a Fräbel Dogwood: Fräbel artist Hung Nguyen shows a completed Dogwood blossom.

Right

Fräbel Studio's "Dogwood with 3 blossoms", 2005

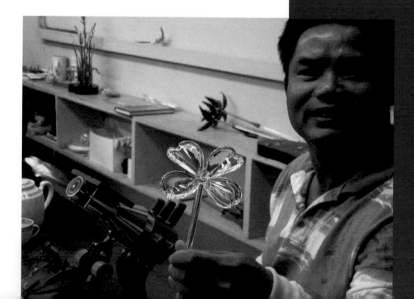

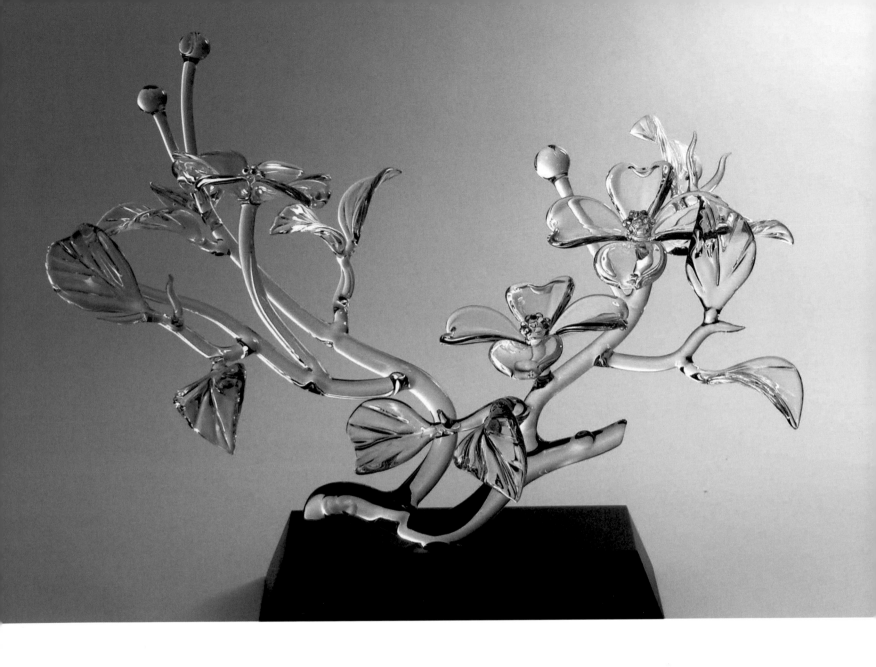

Hollow Glass Sculptures

The technique to create hollow glass sculptures is often referred to as glassblowing. That term will not be used here because it does not properly describe the process with lampwork glass art.

The creation process of a Fräbel teardrop vase is detailed below:

The artist begins by heating one end of a hollow glass tube 2" in diameter, evenly rotating it into the flame to ensure that the walls of the entire tube are properly heated. When the glass turns into a cherry red, the Fräbel artist will pull the glass tube, which thins the tube to a workable scale. The part where the tube is the thinnest will be cut and carefully blown through to create the vase.

The bottom of the tube is closed off by melting the glass until it is air tight.

The center of the tube will be headed and pulled to create a thin "neck" to create two individual spheres by heating the tube and blowing them out to the required size. The thin "neck" will connect both spheres. The bottom sphere will be larger and flattened at the bottom, so it can stand on a flat surface. The top sphere will be blown out slightly smaller.

The creation of a Fräbel Bud Vase:
Heat and then pull the tube on both sides, to create thin ends.

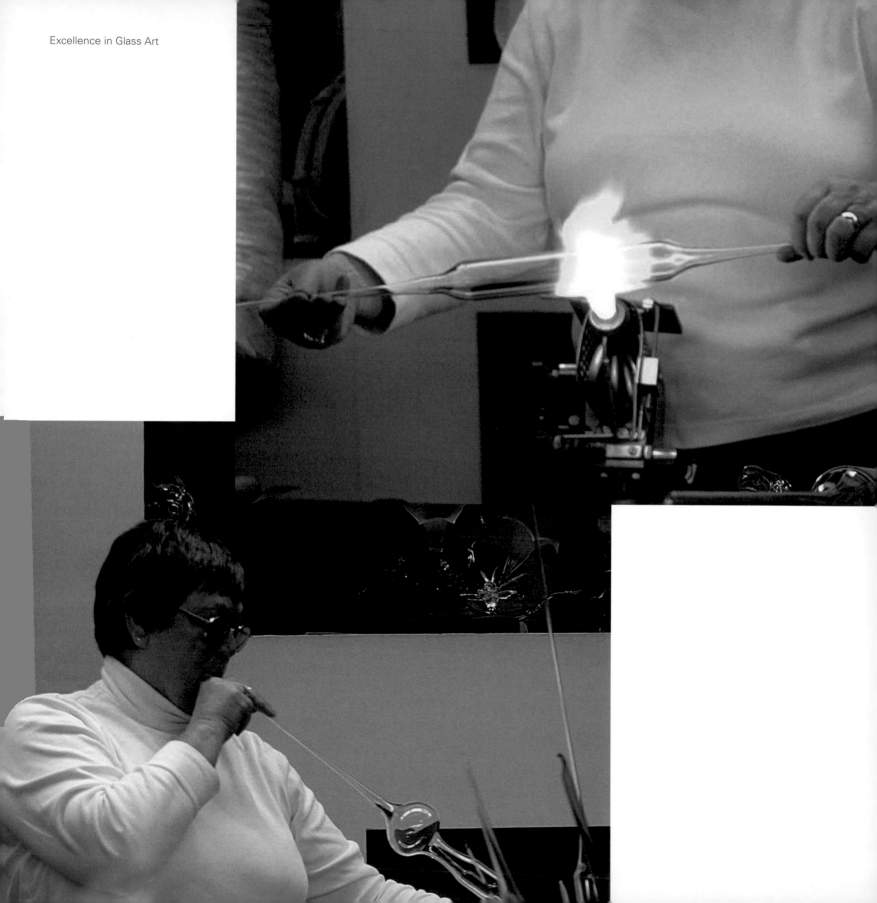

Left

The creation of a Fräbel Bud Vase:
Heat bottom part of the tube until red-hot.

Bottom Left

The creation of a Fräbel Bud Vase:
Blow through the thin part of the tube that is
open and blow the bottom of the vase.

Right

The creation of a Fräbel Bud Vase:
Heat the top part of the tube and blow a smaller
sphere, similar to the bottom part of the vase.

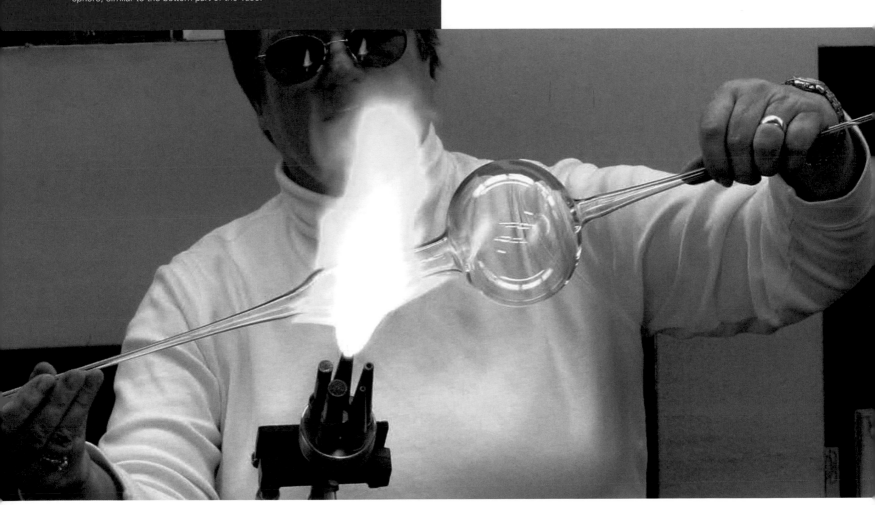

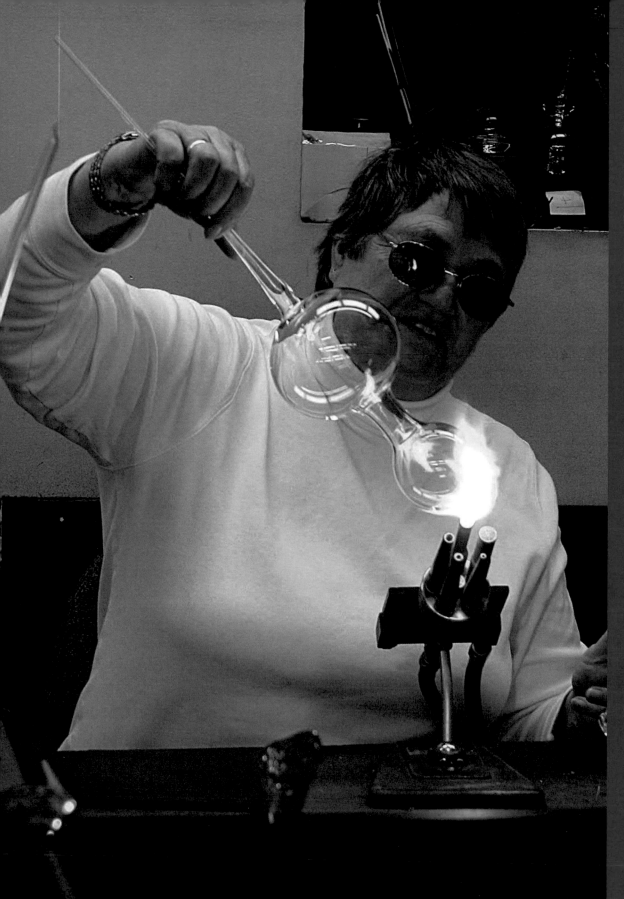

Left

The creation of a Fräbel Bud Vase:
Heat the top of the top sphere.

Right

The creation of a Fräbel Bud Vase:
Blow out the heated area of the top
sphere. The glass that is blown out
becomes thin as foil and will blow
up like a balloon.

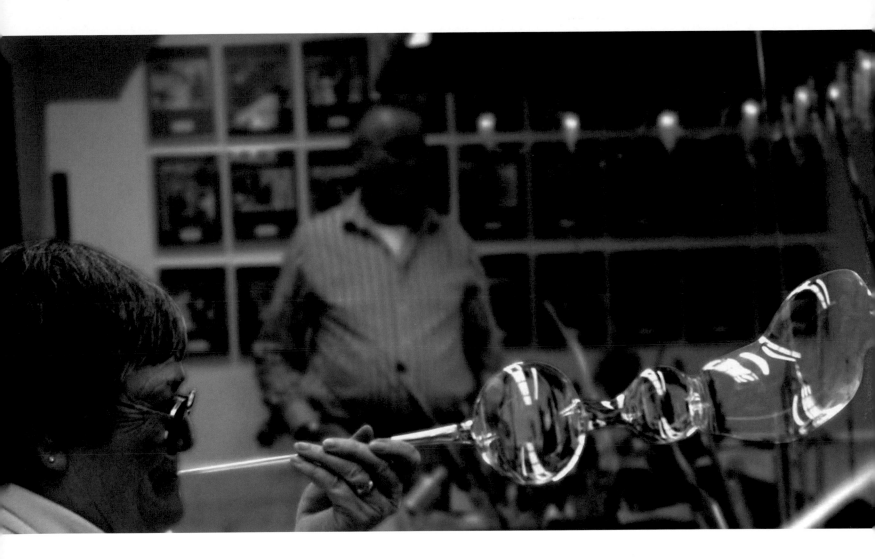

Left

The creation of a Fräbel Bud Vase:
Flame polishing the top of the vase, which is now open, to remove any sharp edges.

Right

The creation of a Fräbel Bud Vase:
Flare out the top of the vase, to create the Bud Vase effect.

Right Below

The creation of a Fräbel Bud Vase:
Fräbel artist Sieglinde Widmann shows a completed Bud Vase.

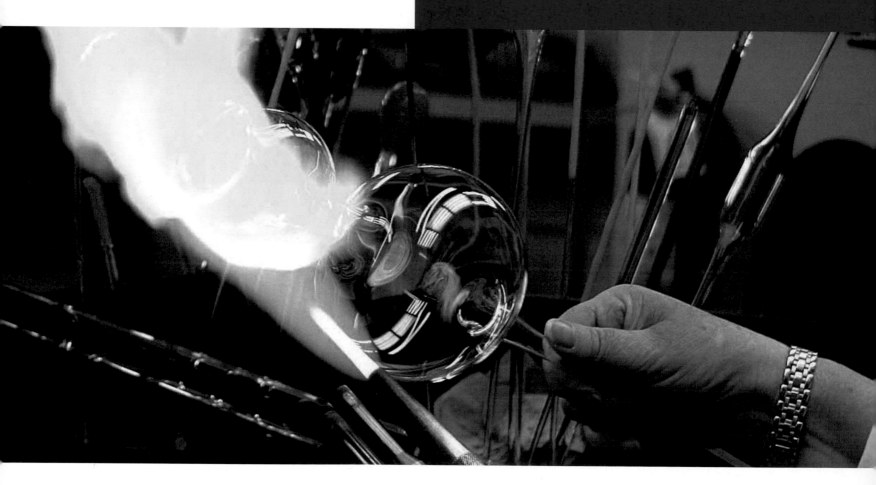

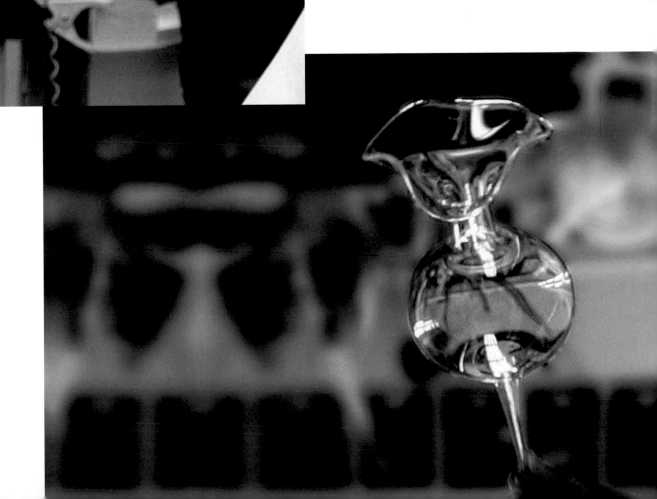

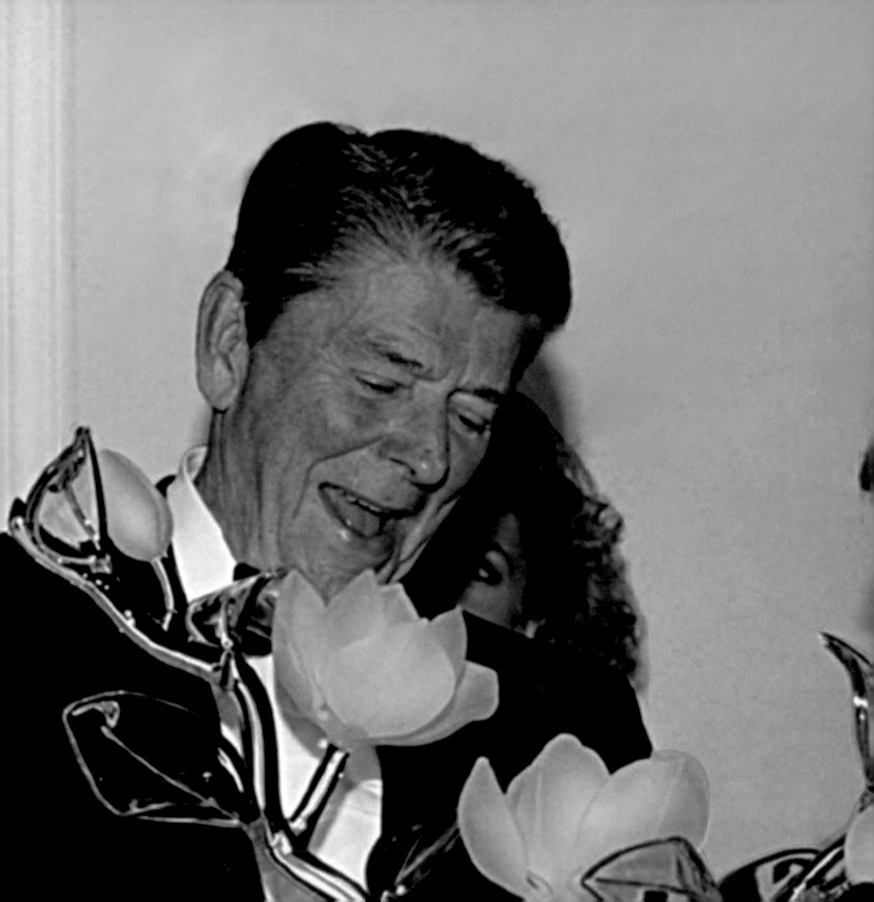

5 Famous Fräbel Art Collectors and Recipients

Famous Fräbel Art Collectors and Recipients

Over the years, the Fräbel Studio has been discovered by famous and not so famous collectors worldwide. Many Fräbel sculptures have been offered as elegant gifts to heads of states, movie stars, entertainers and top-level business executives. A brief overview of some of the more renowned Fräbel owners is presented on the following pages.

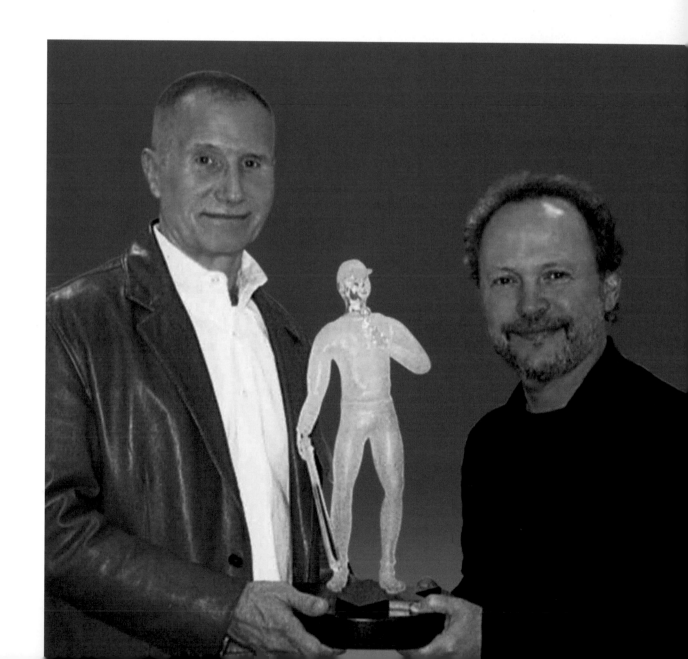

Left

Baseball fan Billy Crystal receives a hollow Fräbel figurine of a baseball player.

Right

Famed songwriter and performer Sir Elton John receives a Fräbel inspired piano. The keys were fashioned to reflect the many different styles of glasses Elton John wears.

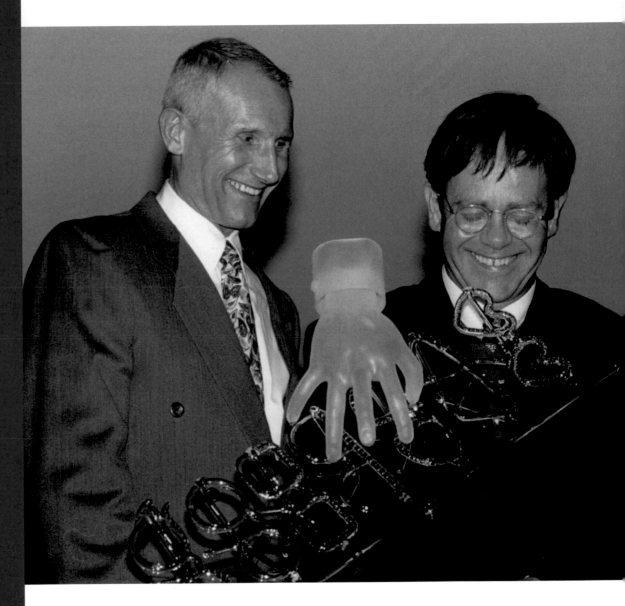

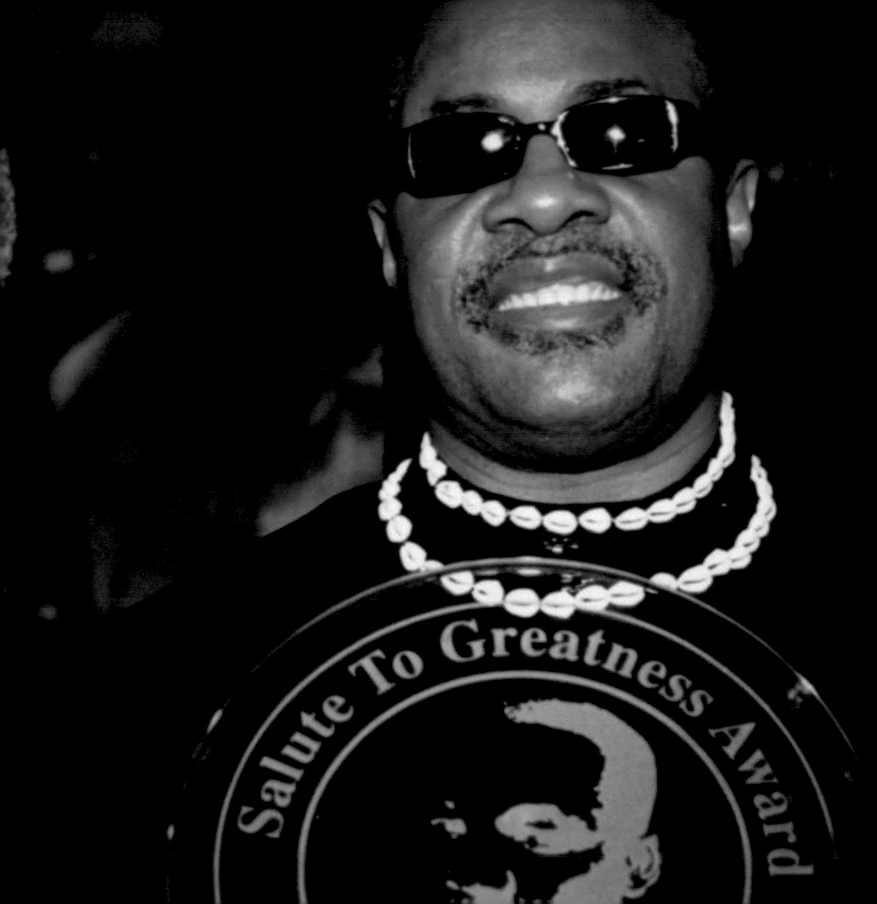

Left

Stevie Wonder receiving the "Salute to Greatness Award", an award designed and created by the Fräbel Studio.

Right

Sting being honored with a Fräbel "Reaching for the Stars" sculpture by the American Screenwriters Association.

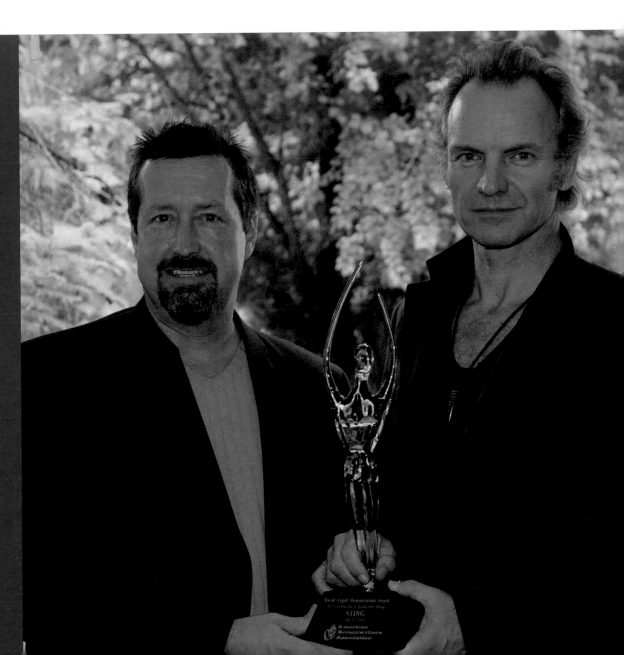

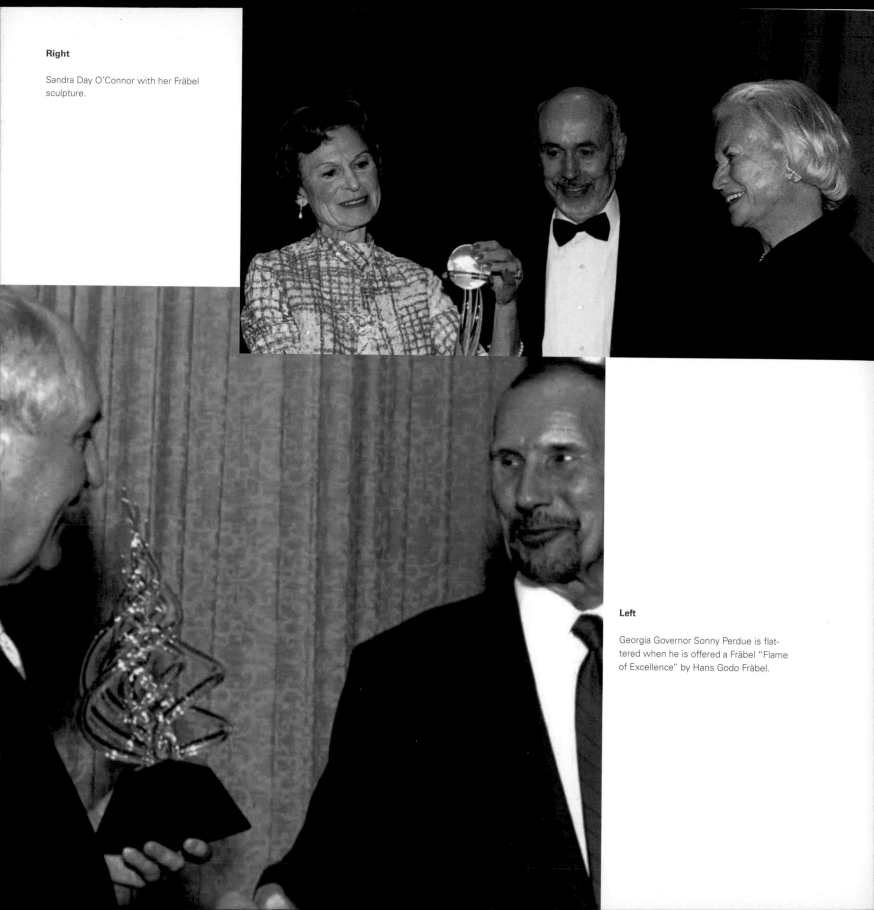

Right

Sandra Day O'Connor with her Fräbel sculpture.

Left

Georgia Governor Sonny Perdue is flattered when he is offered a Fräbel "Flame of Excellence" by Hans Godo Fräbel.

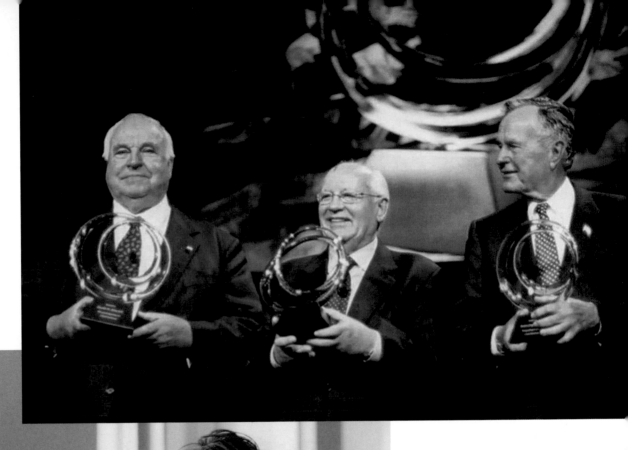

Right

German President Helmut Kohl, Russian President Mikhail Gorbachev and US President George Bush receiving a Fräbel Moebius Loop as an appreciation gift.

Left

Jane Fonda with some of the Fräbels in her collection.

95

Excellence in Glass Art

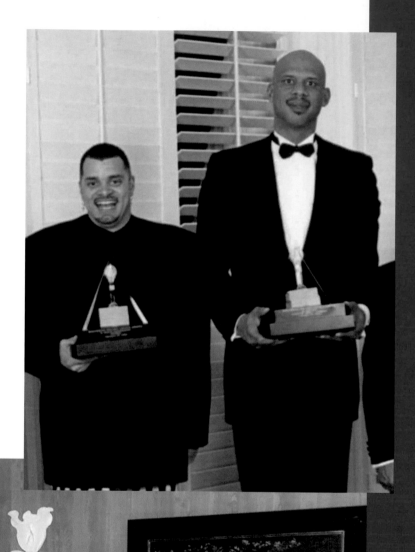

Left

Entertainer Sinbad and
Basketball legend Kareem
Abdul-Jabbar awarded
with a Fräbel sculpture.

Left Bottom

Oprah Winfrey with her
specially commissioned Fräbel
Flower Garden.

Right

Prince Philip, Duke of Edinburgh,
receiving a Fräbel Outline Peach
as a Georgia welcoming gift.

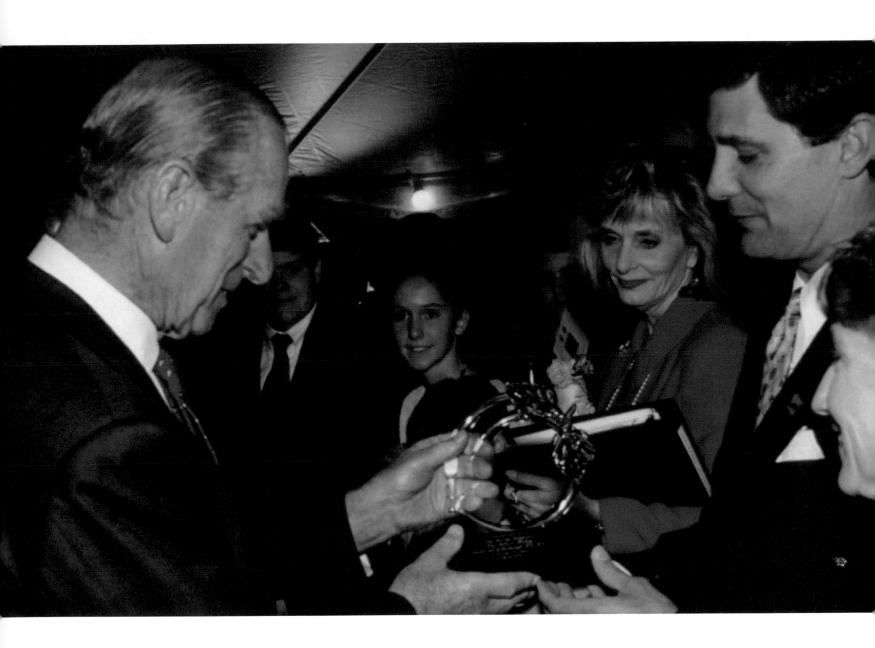

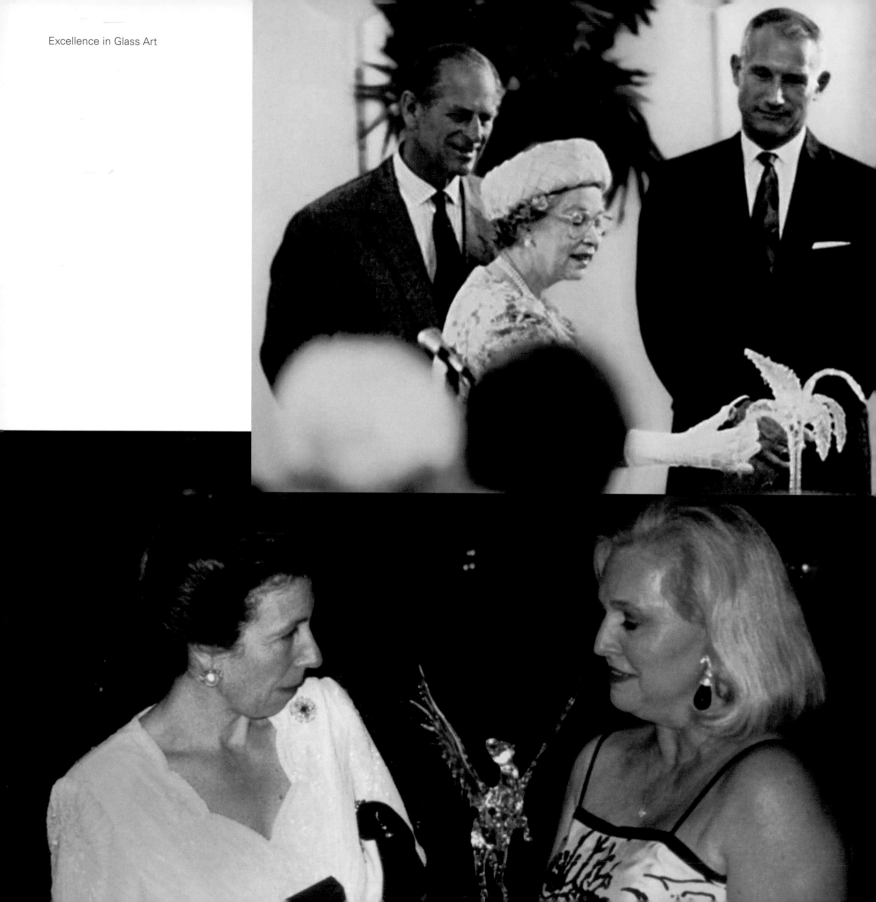

Top Left

Queen Elizabeth II of Great Britain receiving a Fräbel Crystal Palm tree from Hans Godo Fräbel as a welcoming gift from the City of Tampa.

Bottom Left

Princess Anna of Great Britain receiving a Fräbel Pegasus.

Right

Coretta Scott King offers Nelson Mandela a uniquely created Fräbel Phoenix. The picture shows part of the words of appreciation President Nelson Mandela wrote to Hans Godo Fräbel.

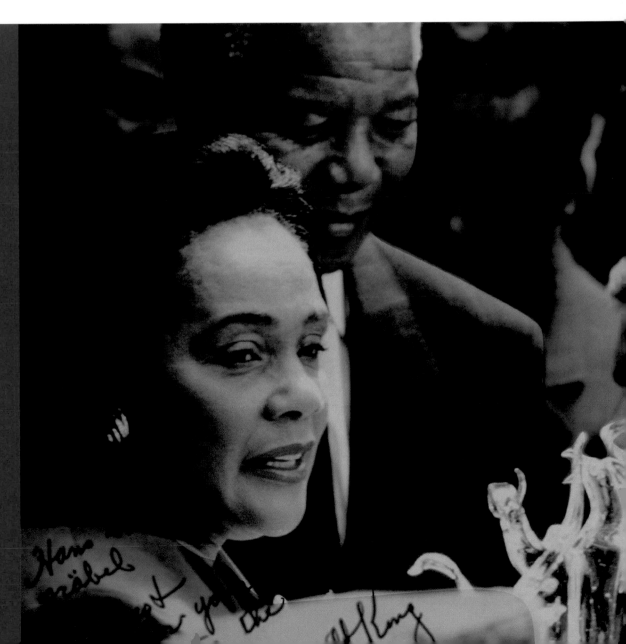

Left

Gary Sinise receives a Fräbel Kite as a token of appreciation for his tireless charitable efforts.

Right

Lance Armstrong receives the Fräbel Tour de Georgia Trophy, which was specially designed by Hans Godo Fräbel as an award for the Tour de Georgia.

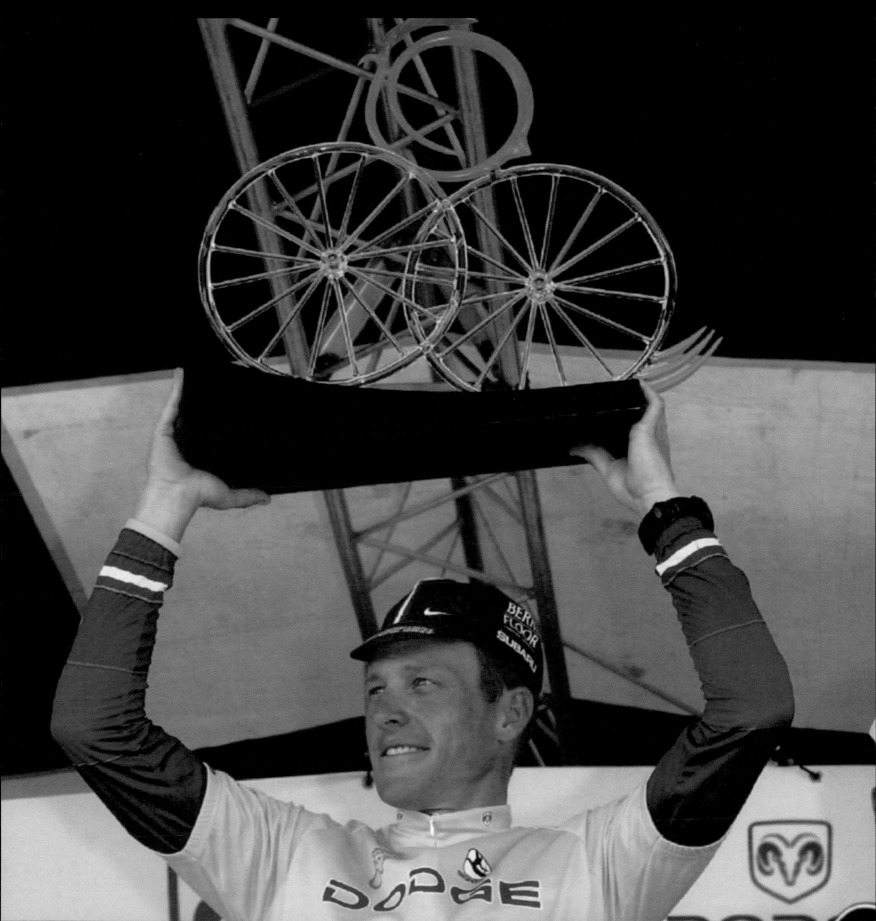

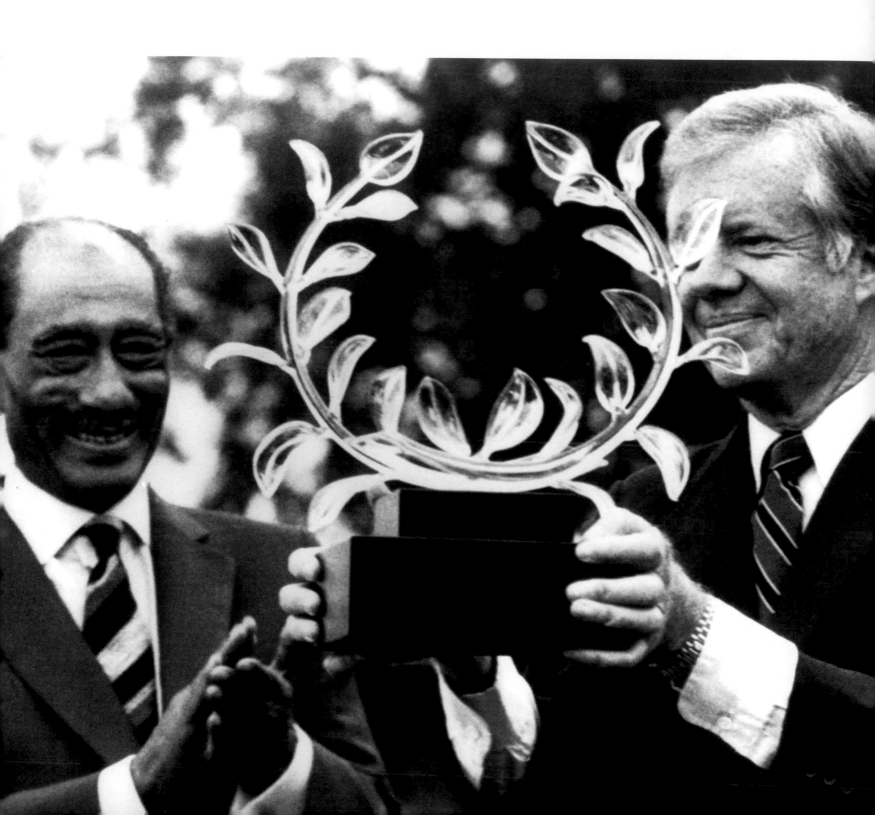

Left

President Jimmy Carter presenting Egyptian President Anwar Sadat with a specially commissioned Fräbel Peace Wreath to honor his efforts to start the peace process in the Middle East. A replica of this unique Fräbel Peace Wreath is on display at the Carter Center in Atlanta, Georgia.

Right

Larry King receives a Fräbel Entwined Heart to celebrate the accomplishments of the Larry King Cardiac Foundation, which helps many disadvantaged heart patients to receive the medical treatment they need.

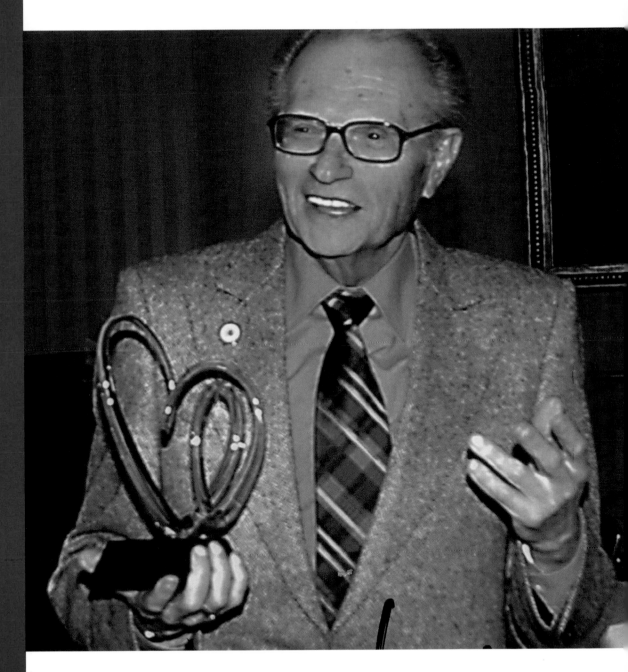

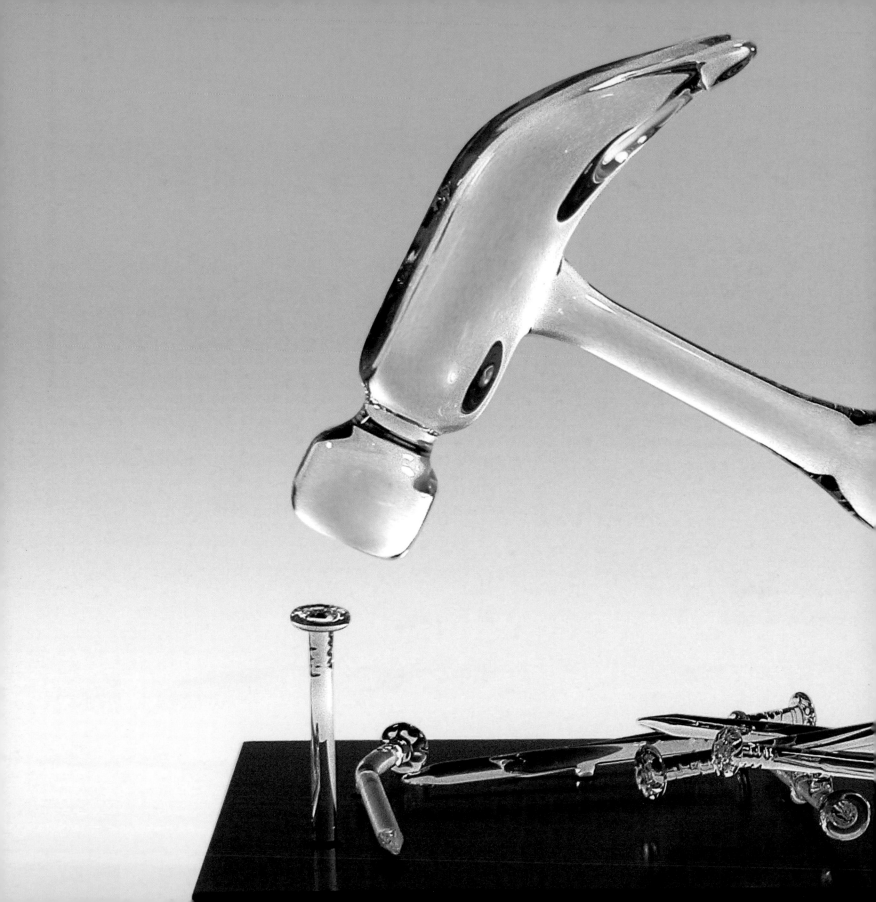

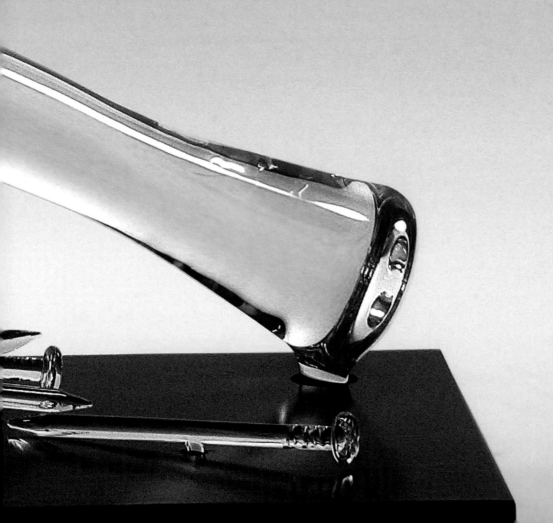

6 Famous Fräbel Sculptures

Famous Fräbel Sculptures

Under the guidance of Hans Godo Fräbel, the artists of the Fräbel Studio have created many distinguished glass sculptures, which can be found in the collections of museums and private collectors around the globe. Some of the most famous Fräbel sculptures are highlighted in this chapter.

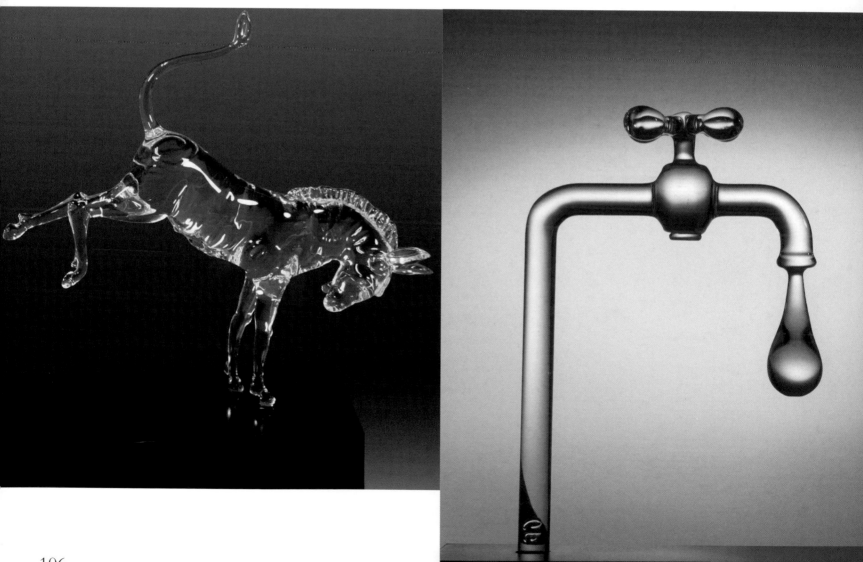

Far Left

"Glass Donkey" by Hans Godo
Fräbel, 1976.

The Democratic Party of Georgia
commissioned this sculpture for
President Jimmy Carter, which graced
the President's desk in the Oval Office
during his presidency.

Near Left

"In the Middle of the Night" by Hans
Godo Fräbel, 1976.

This sculpture of an exaggerated drop
of water hanging on a faucet, frozen in
time, is in the permanent collection of
the Smithsonian Institution in Wash-
ington D.C.

Right

"The Cavorting Clowns" by Hans Godo
Fräbel, 1987

The famed Cavorting Clowns sculpture
that was utilized by the Absolut Vodka
Company in their advertisements from
1987 until the early 1990's.

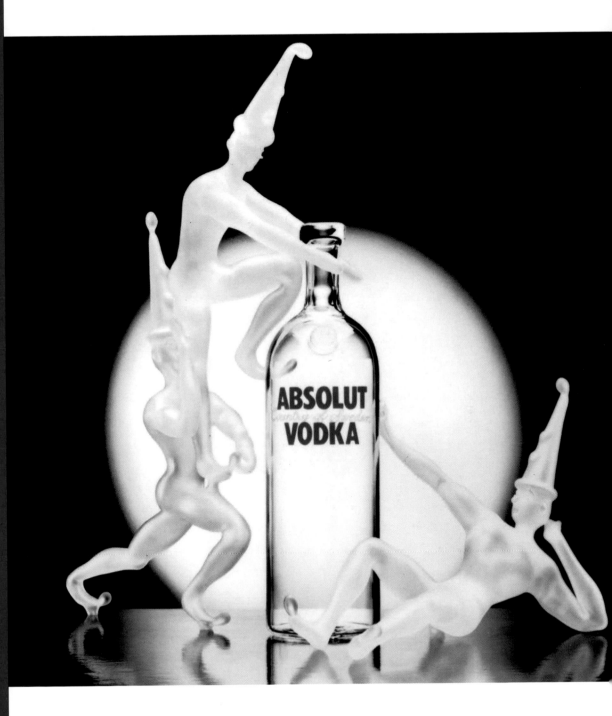

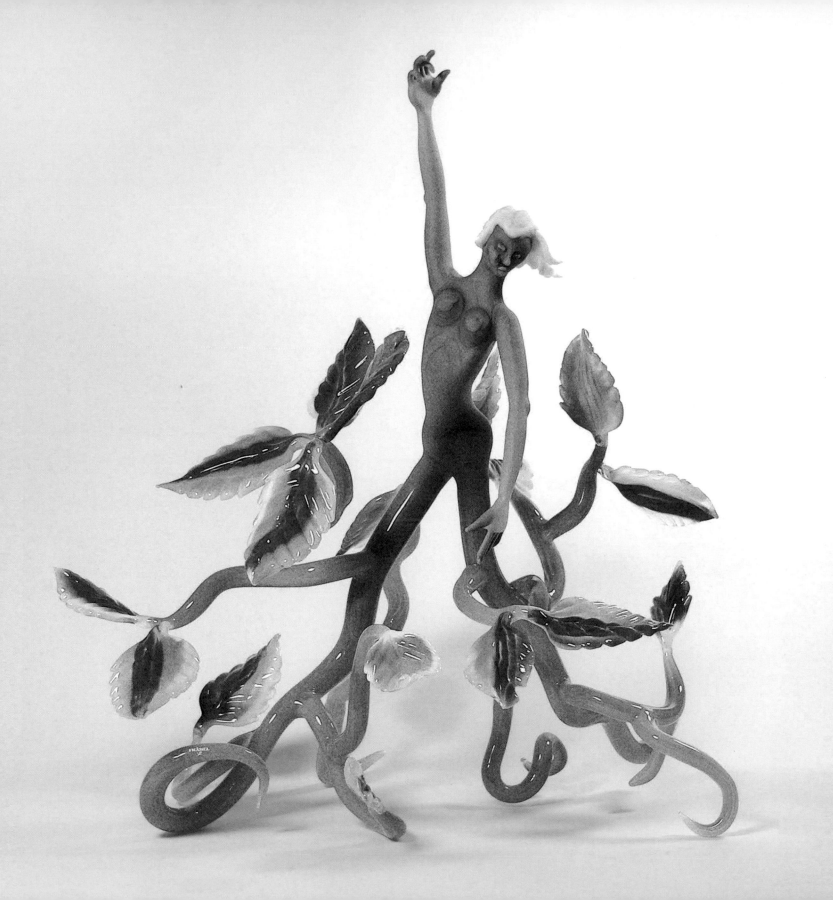

Left

"Viney 8" - Hans Godo Fräbel, 2006.

In the late 1990's, Hans Godo Fräbel created a series of "Viney's", half human, half plant or flower. Since then, Fräbel has made several variations on that theme, creating fantastic and whimsical glass sculptures that stimulate the imagination.

Right

"Profile Flower 2" by Hans Godo Fräbel, 2000.

Out of the series "Profiles", which are outlines of faces, where the hair is made up of flowers or leaves. The first time Fräbel created such a "Profile" dates back to the mid 1970's. One of these very first "Profiles" can be found in the permanent collection of the Corning Museum of Glass in Corning, New York.

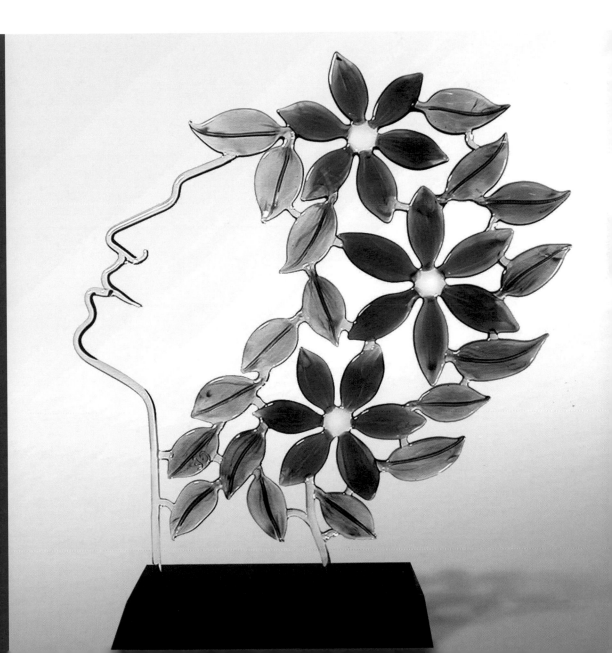

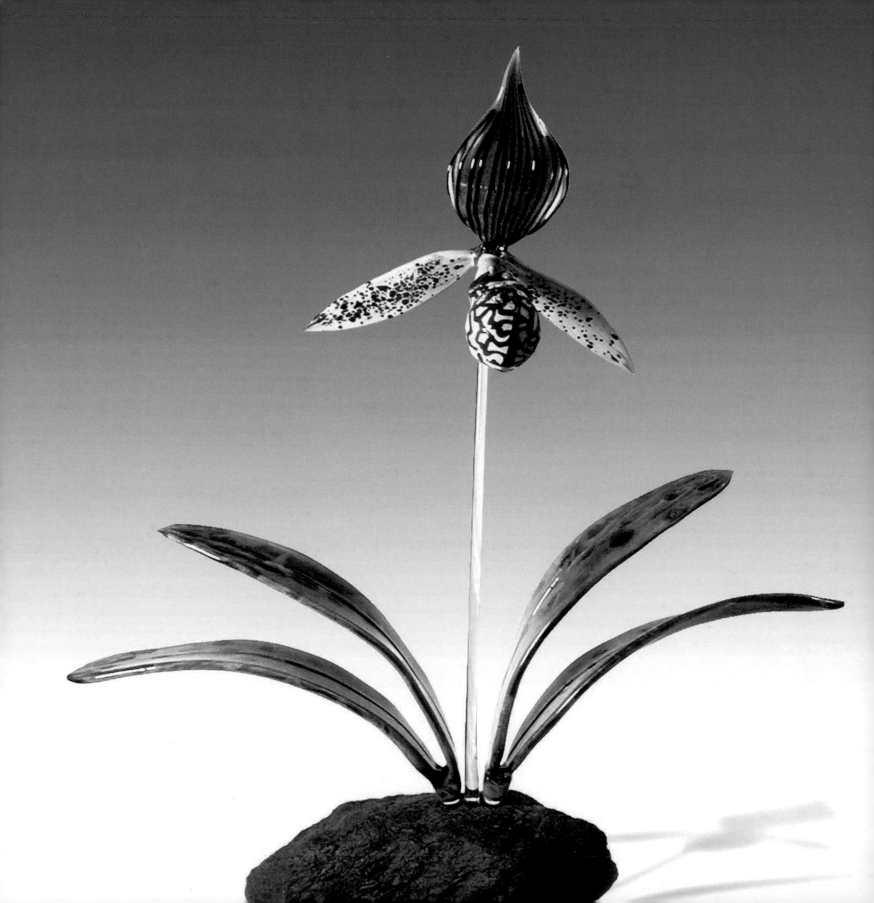

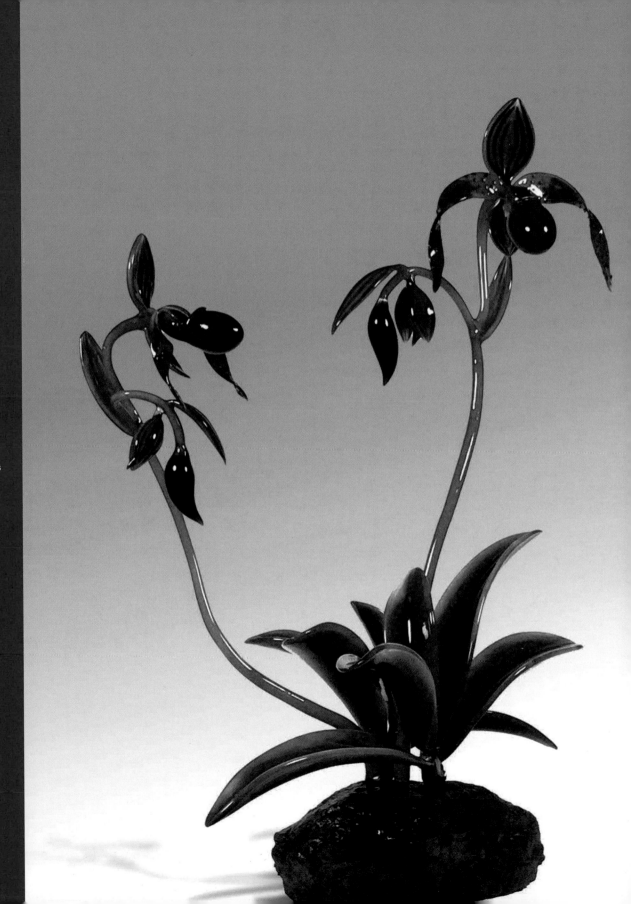

Left

"Fantasy Lady Slipper", Hans Godo
Fräbel, 2003.

Hans Godo Fräbel and the Fräbel Studio
are famous for the many glass sculptures
they have created of beautiful flowers,
such as this Orchid. This Fräbel Orchid
was on display during a Fräbel Orchid
Exhibition at the State Botanical Garden
in Athens in 2004.

Right

"Paphiopedilum rothschildianum
Orchid" - Hans Godo Fräbel & Hung
Nguyen, 2006.

In 2006, Hans Godo Fräbel and the
Fräbel artists began working on a series
of very rare and extinct orchids to give
orchid enthusiasts the opportunity to get
a realistic 3 dimensional impression of
these rarefied treasures of the earth. This
Fräbel sculpture of a "Paphiopedilum
rothschildianum variation" is an endan-
gered orchid from South America and
was on display at the Atlanta Botanical
Garden in 2007.

Below

"Zachor" by Hans Godo Fräbel, 1991.

Fräbel said to have tried to relate three distinct perspectives or impressions of the Holocaust, beginning first with his own, very personal experience as a child in that time. He had the incredible misfortune of losing a child friend in that horror and of actually seeing the broken remnants of that friend. This sculpture was called "Zachor" in memory of Fräbel's childhood friend.

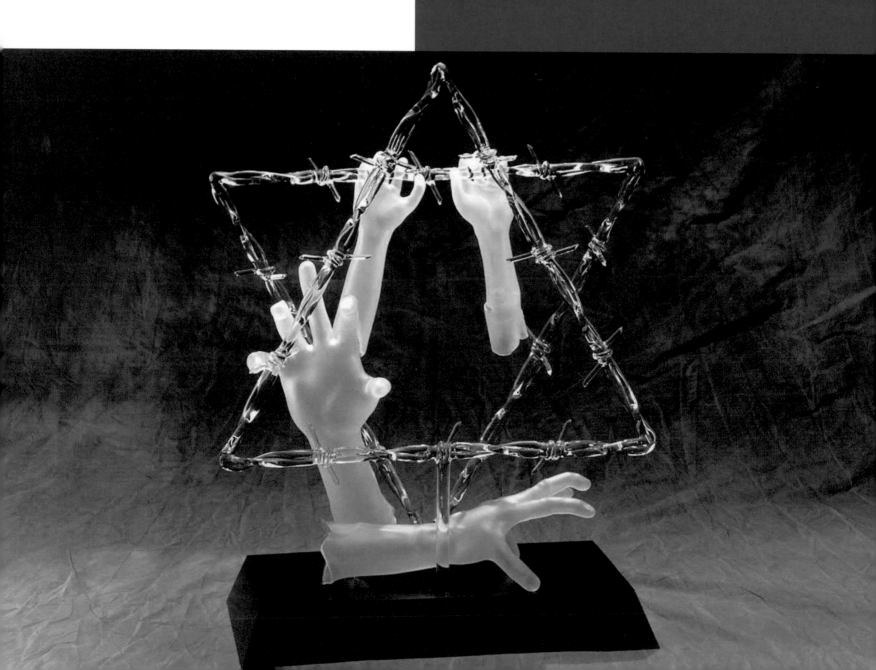

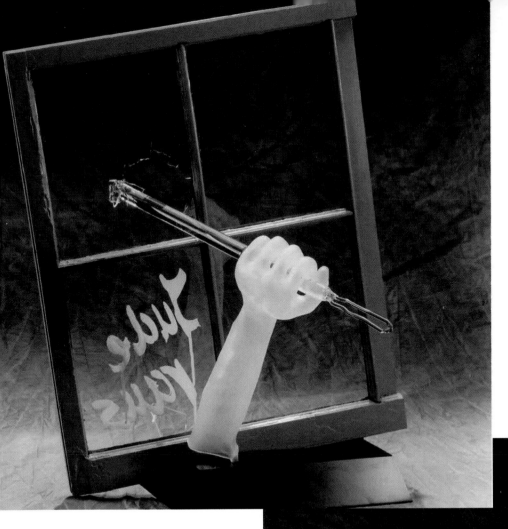

Left

"Kristallnacht" by Hans Godo Fräbel, 1991

In this conception, 11.9.38, Fräbel said he sought to present a two-faced sculpture somewhat like Janus of ancient times. He invited the viewer to experience the terror from the standpoint of a Jewish child in a room looking out to the fist of hate, or simply to go to the other side and see the same scene from the standpoint of the venomous hoodlum.

Below

"Liberation" by Hans Godo Fräbel, 1991

In this perspective Fräbel said he wanted to find a distinct Jewish perspective. He sought this by tying the crystal barbed wire into the symbol of those who bore the brunt of the hate. Fräbel called it 4.8.45 "Liberation" because he saw it exemplifying the hope (finally fulfilled) of the continued existence of a people under a genocide attack.

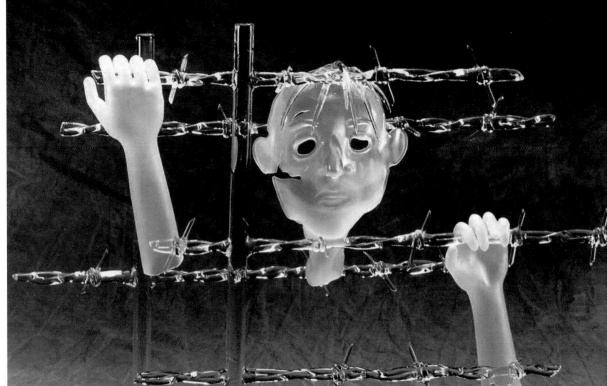

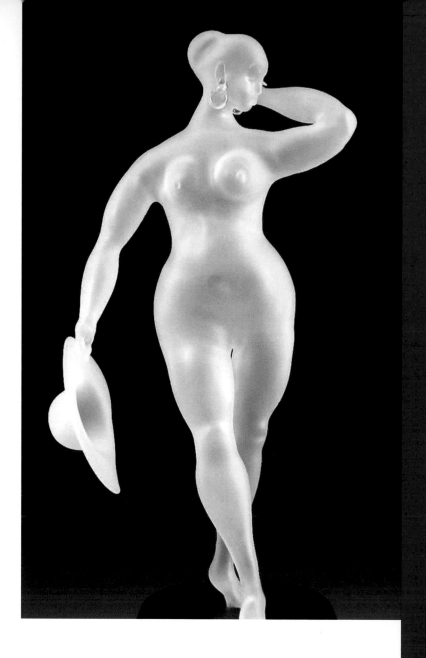

Left

"Venus with Hat", Hans Godo Fräbel, 2004.

One of Hans Godo Fräbel's trademarks is his incredible ability to create humanlike hollow figurines. This "Venus with Hat" sculpture is from the series "Venus Atlantis" and focused on the elegant qualities of voluptuous women, which was created by Hans Godo Fräbel in 2004.

Right

"Venus with Ribbon", Hans Godo Fräbel, 2004.

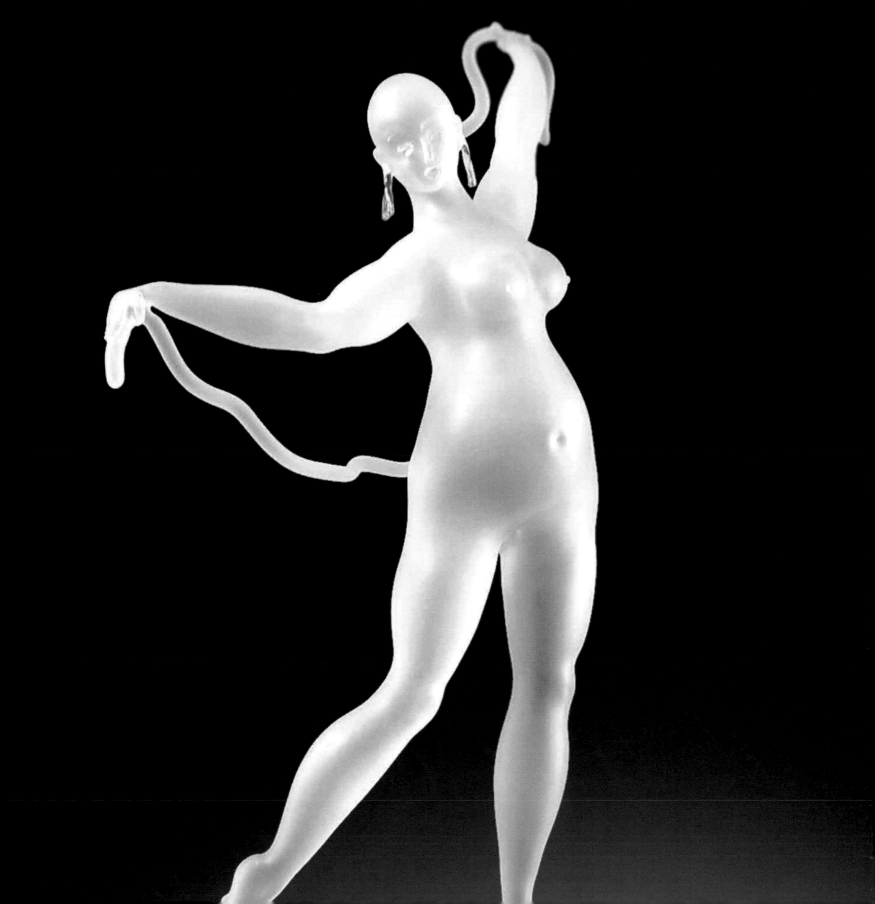

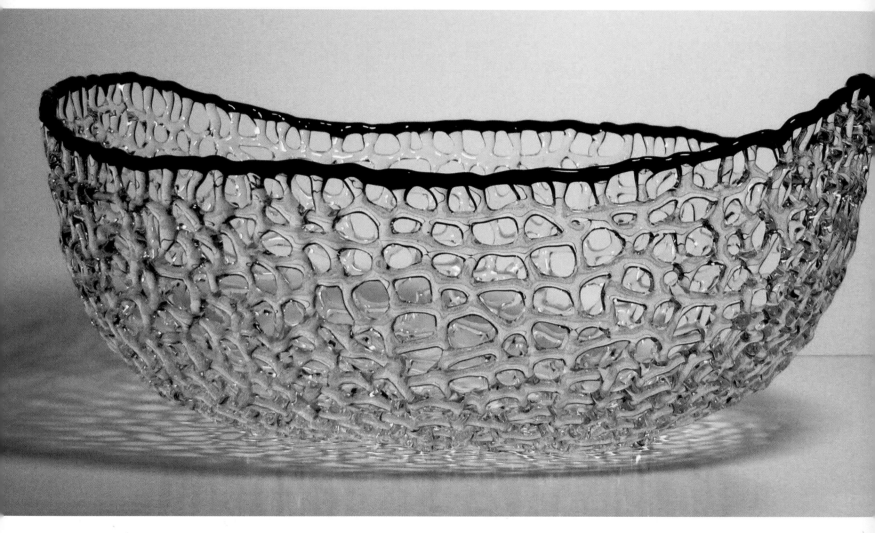

Above

"Wavy Bowl with Black Edge", Hans Godo Fräbel, 2006.

In 2006, Hans Godo Fräbel created a series of large glass "woven" bowls, 15 to 20 inches in diameter. The stringing of the glass creates a magical play with light, one can fully enjoy once the bowl has been placed in a well lit spot.

Right

"Royal Palm Tree", Hans Godo Fräbel, 1991.

Created especially for Queen Elizabeth II in honor of her visit to the city of Tampa in 1991.

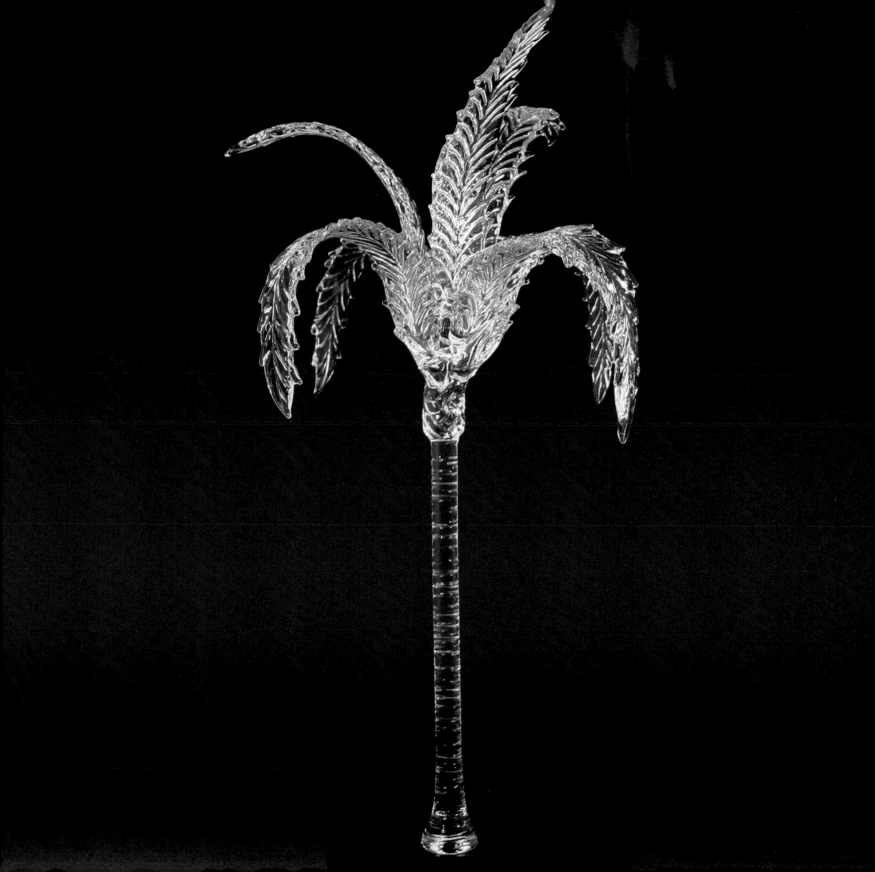

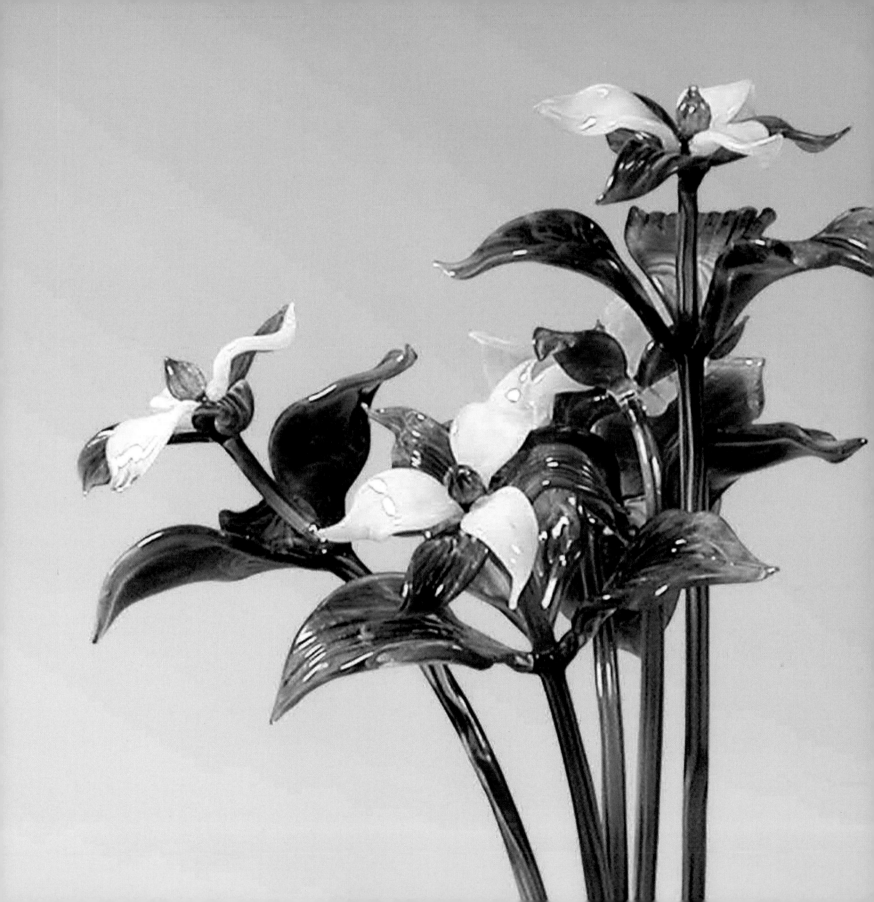

Fräbel Studio Designs

Under the Studio line of the Fräbel Studio, the artists collaborate to create a beautiful line of "multiple originals." These sculptures are not limited in number, but each unique design is created for a specific period of time.

One of the notable glass artists of the Fräbel Studio will create an original glass sculpture, which is then recreated by one of the Studio Artists. Each of those sculptures is completely handmade; therefore, like a fingerprint, no two Fräbel sculptures are ever exactly alike.

Left

Commissioned by the Coca Cola Company in celebration of the 20th anniversary of Cici's Pizza. The Fräbel artists created a custom sculpture that would show a powerful sign of appreciation for the business relationship between Coca Cola and Cici's Pizza.

Right

"Inkwell", designed by Hans Godo Fräbel & Sieglinde Widmann, 1975.

The Inkwell with Quill Pen is often utilized as a tribute to creative minds who successfully create and convey their ideas.

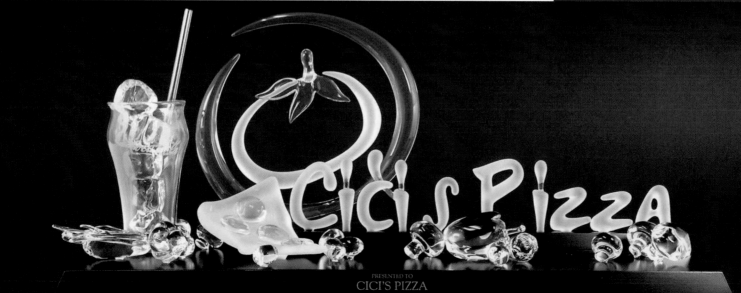

PRESENTED TO
CICI'S PIZZA
IN CELEBRATION OF YOUR 20TH ANNIVERSARY
1985 - 2005
FROM YOUR FRIENDS AT COCA-COLA

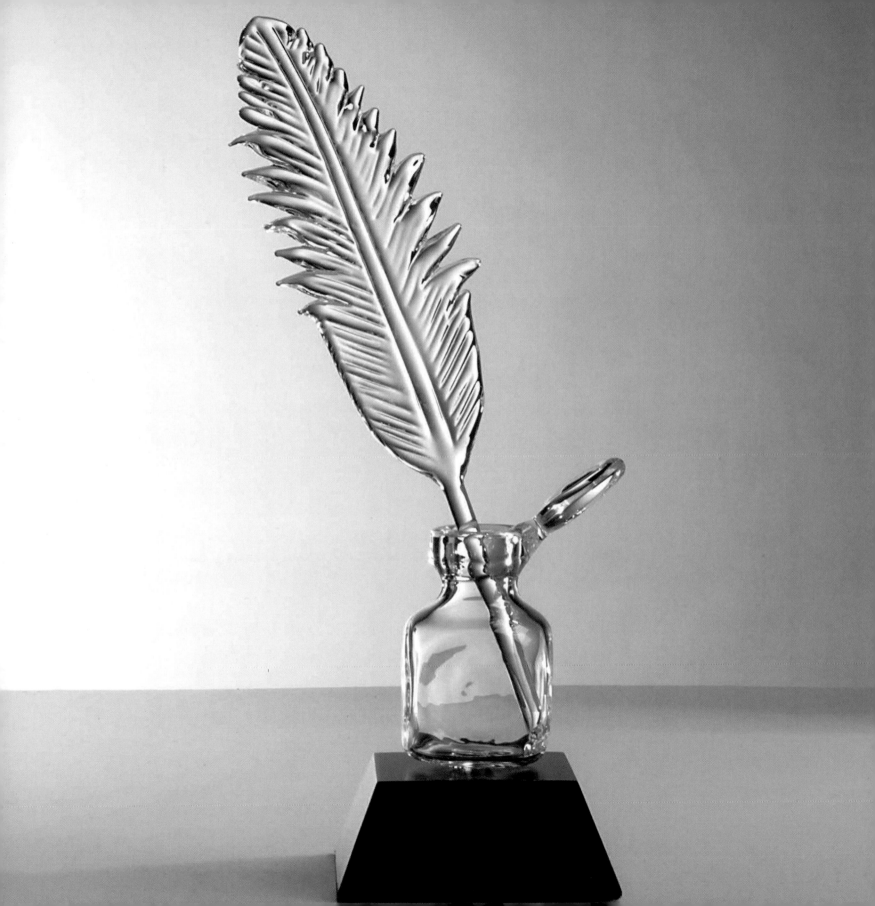

Right

Fräbel Studio's "Brown Thrasher on Cherokee Rose", 2003.

The Brown Thrasher is the State Bird of Georgia and the Cherokee Rose is the official State Flower of Georgia.

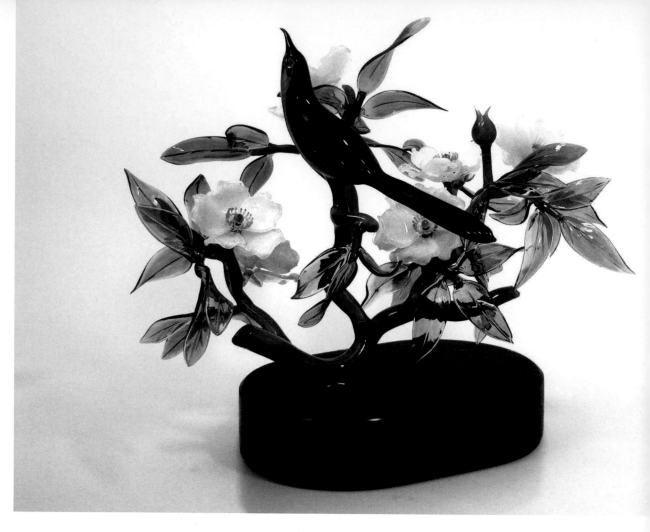

Left

Drawing of Fräbel Studio's "Brown Thrasher on Cherokee Rose", 2003. With commissioned sculptures, the artists of the Fräbel Studio create a design on paper to get the approval of the client. Normally, Fräbel artists do not first draw a design, but rather create it immediately in glass. Only when a client has to approve a design, it is drawn on paper first, since drawing takes much less time than sculpting in glass. Also, if the design is very complex, such as a large flower composition, it is drawn out to get a good idea of the composition before the artist starts with the creation of the sculpture.

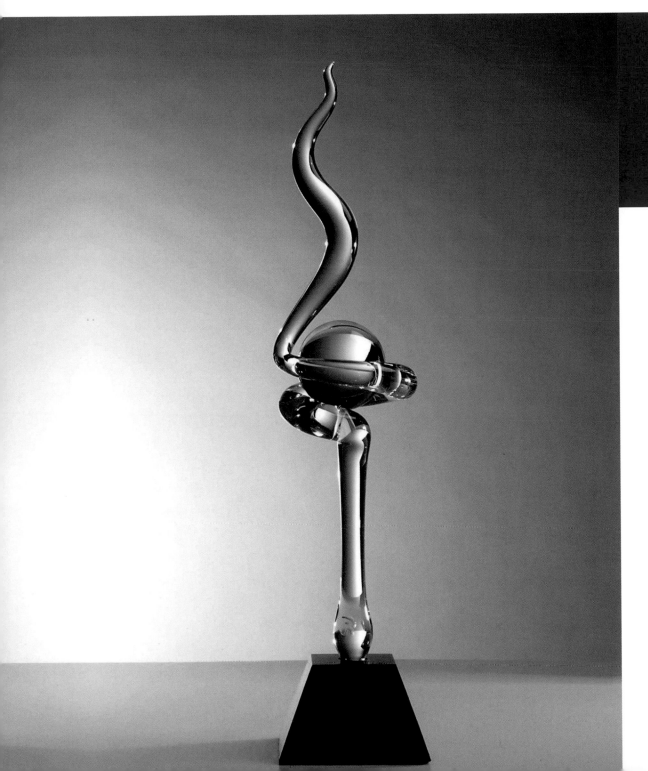

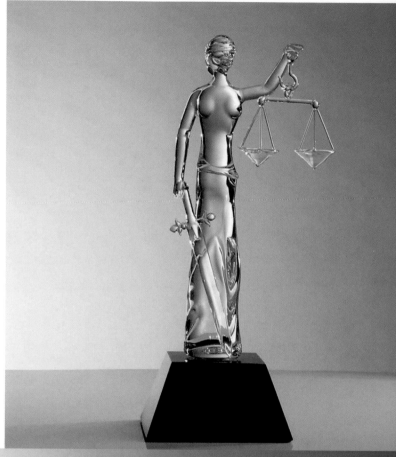

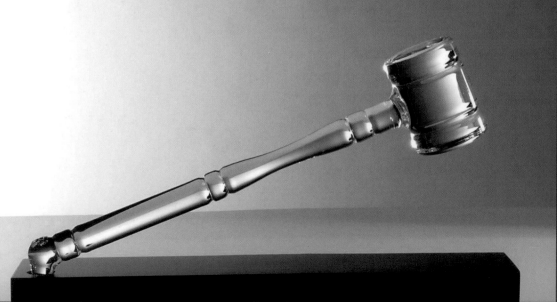

Top Left

"Lady Justice", designed by Hans Godo Fräbel & Sean Thomson Short, 2005.

The Fräbel Studio has created several abstract and realistic depictions of Lady Justice since 1970. The most recent Studio design of the Lady Justice dates from 2005 and is shown in this picture.

Bottom Left

"Gavel", designod by Hans Godo Fräbel, 1972.

The crystal Gavel represents authority, leadership and focus. The Fräbel Gavel has been a popular gift for retiring judges, politicians and heads of various boards.

Right

"Moebius Loop", designed by Hung Nguyen, 1995.

This crystal abstract of the famous Moebius Loop was designed by Fräbel Artist Hung Nguyen.

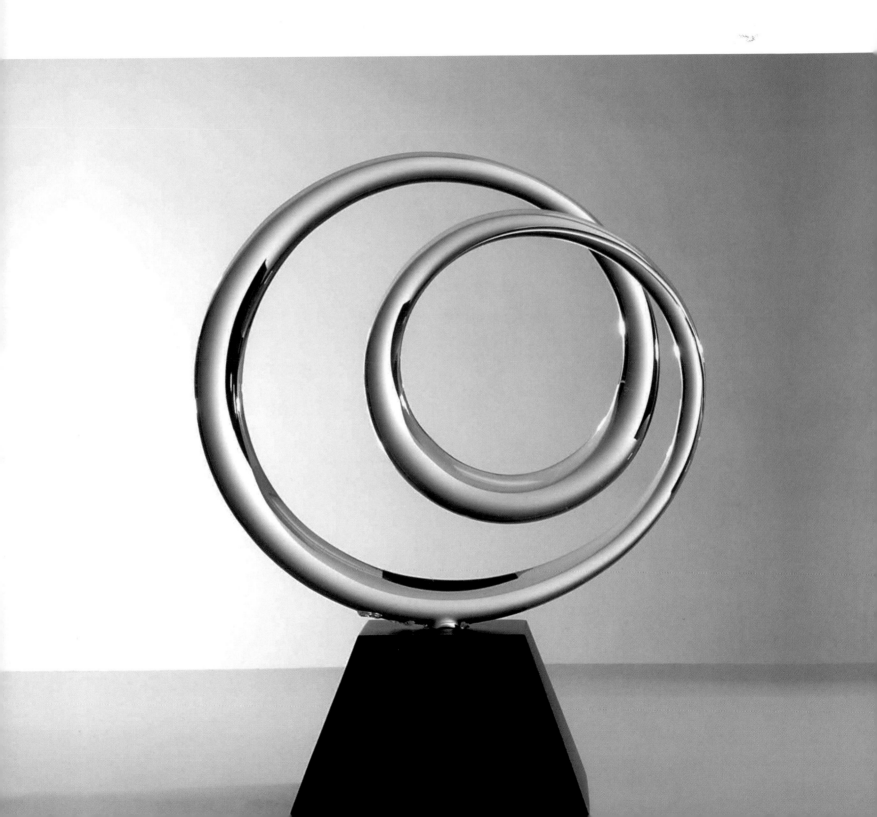

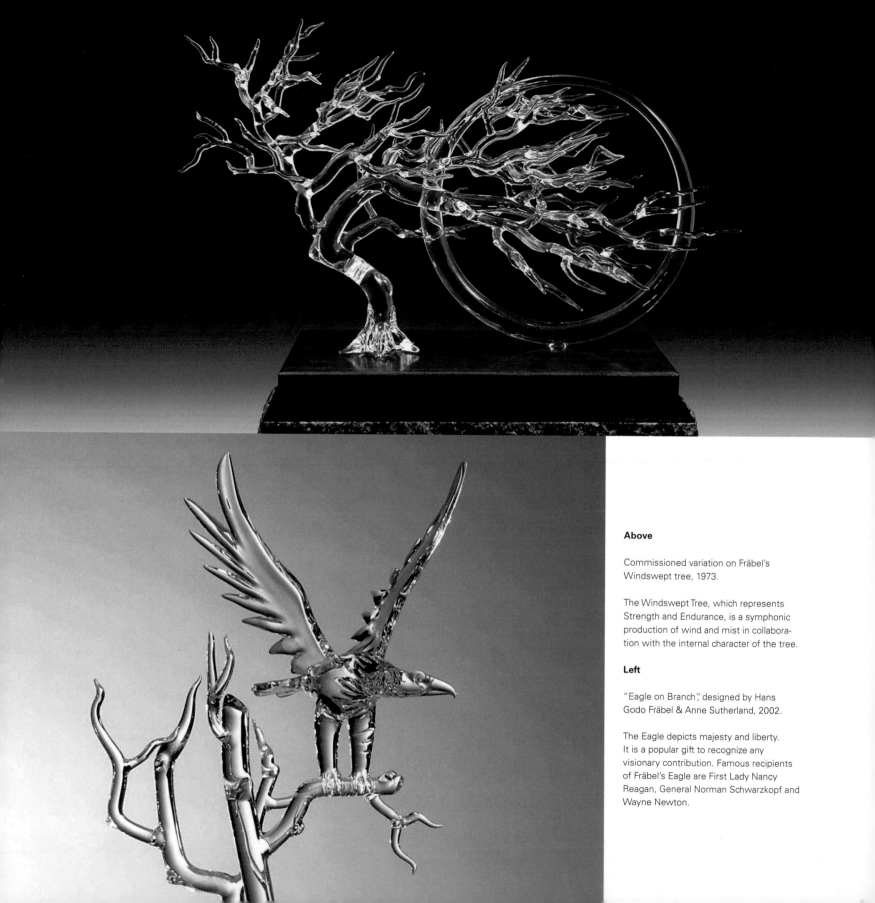

Above

Commissioned variation on Fräbel's Windswept tree, 1973.

The Windswept Tree, which represents Strength and Endurance, is a symphonic production of wind and mist in collaboration with the internal character of the tree.

Left

"Eagle on Branch", designed by Hans Godo Fräbel & Anne Sutherland, 2002.

The Eagle depicts majesty and liberty. It is a popular gift to recognize any visionary contribution. Famous recipients of Fräbel's Eagle are First Lady Nancy Reagan, General Norman Schwarzkopf and Wayne Newton.

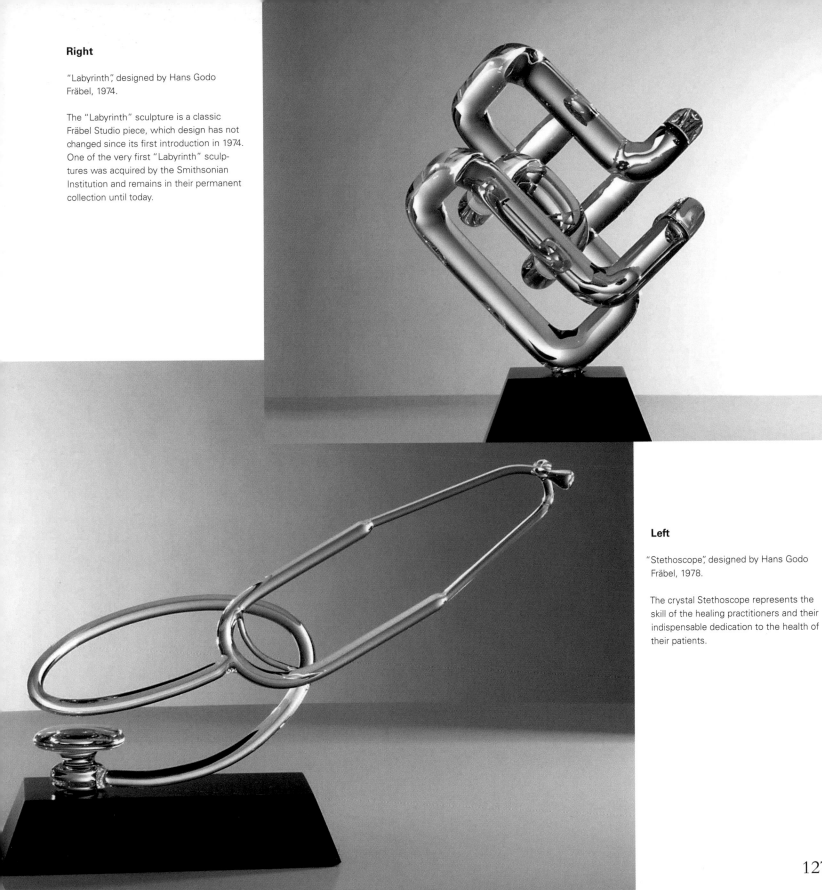

Right

"Labyrinth", designed by Hans Godo Fräbel, 1974.

The "Labyrinth" sculpture is a classic Fräbel Studio piece, which design has not changed since its first introduction in 1974. One of the very first "Labyrinth" sculptures was acquired by the Smithsonian Institution and remains in their permanent collection until today.

Left

"Stethoscope", designed by Hans Godo Fräbel, 1978.

The crystal Stethoscope represents the skill of the healing practitioners and their indispensable dedication to the health of their patients.

127